Landmarks of the World

Color Your Way from Barcelona to Beijing

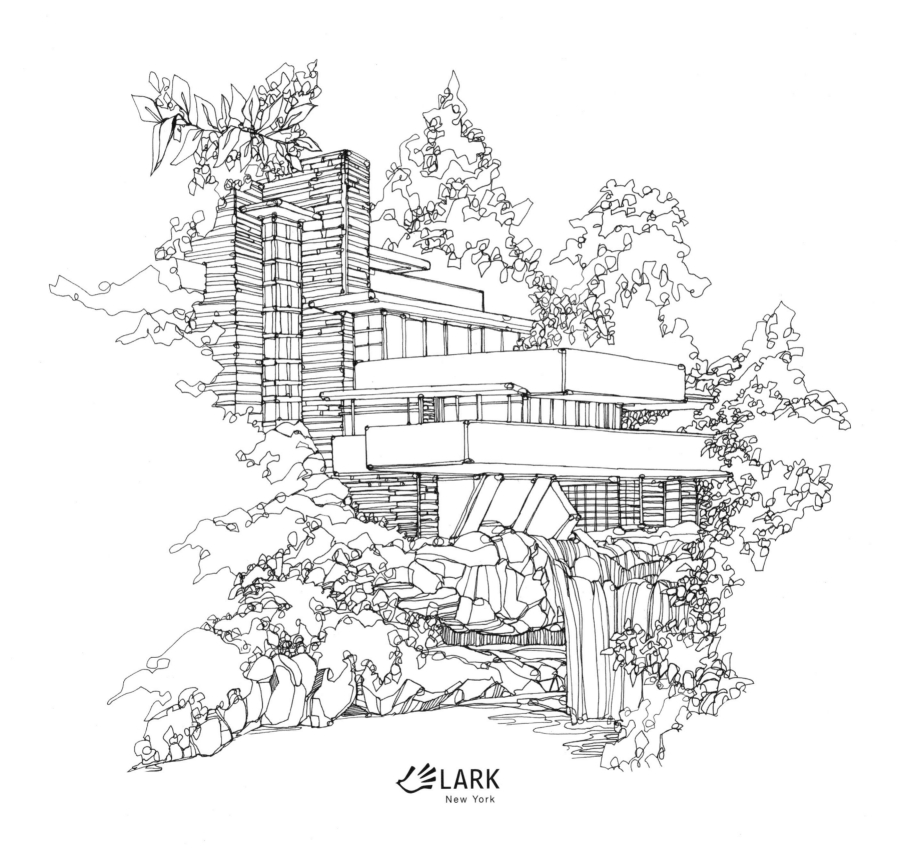

LARK
New York

Contents

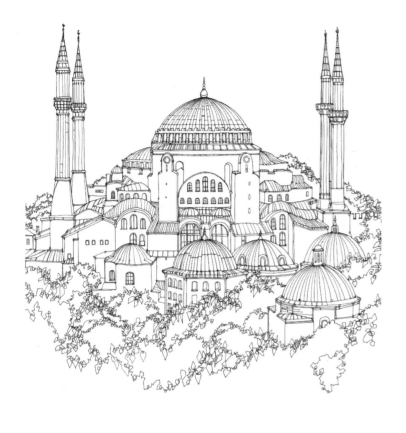

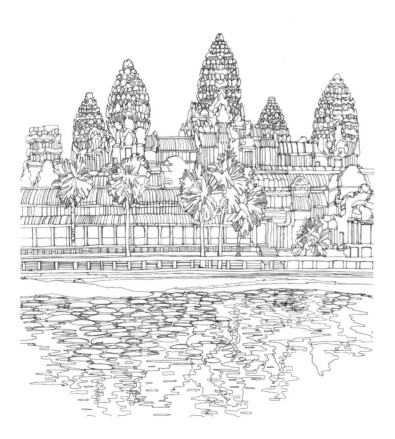

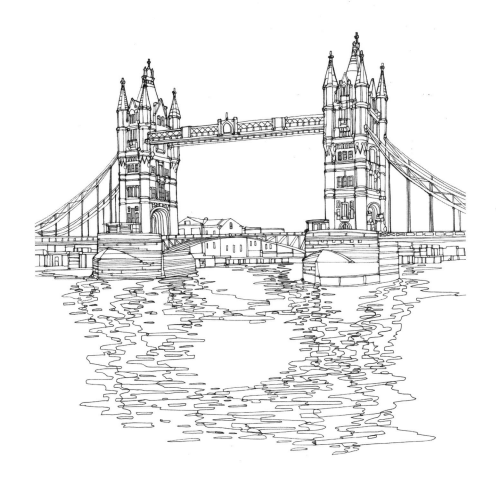

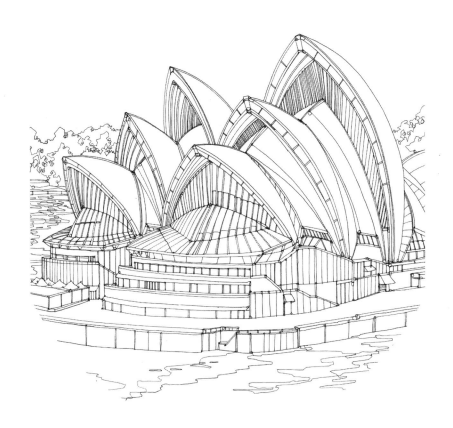

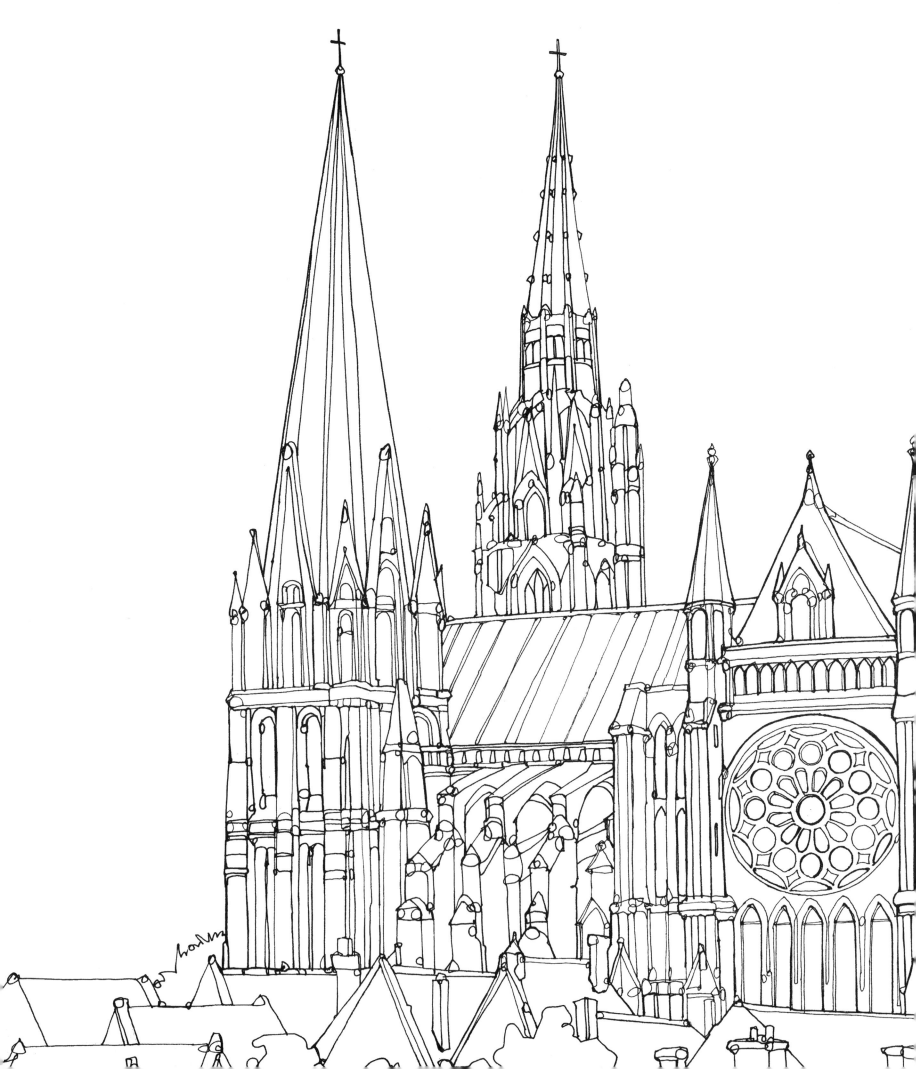

Introduction

Ever since I was little I have loved to draw buildings. Whether as illustrated maps, cityscapes or single structures, the sheer scale of architecture allows for so much detail and can be utterly engrossing. When I start an illustration I usually create a pencil sketch first, before drawing in the final image in ink. Sometimes I add color on the computer, or I might add in touches of watercolor or pastel to the original drawings. However, you can use any medium you prefer when coloring these images yourself.

Landmarks of the World contains 35 remarkable buildings presented in chronological order for you to explore and lose yourself in. Whether you're stepping into the sun-warmed squares of the Alhambra in Granada, imagining snow falling over the famous onion domes of Saint Basil's Cathedral in Moscow, or climbing to the top of the Empire State Building, I very much hope you enjoy the trip as much as I did.

Abi Daker

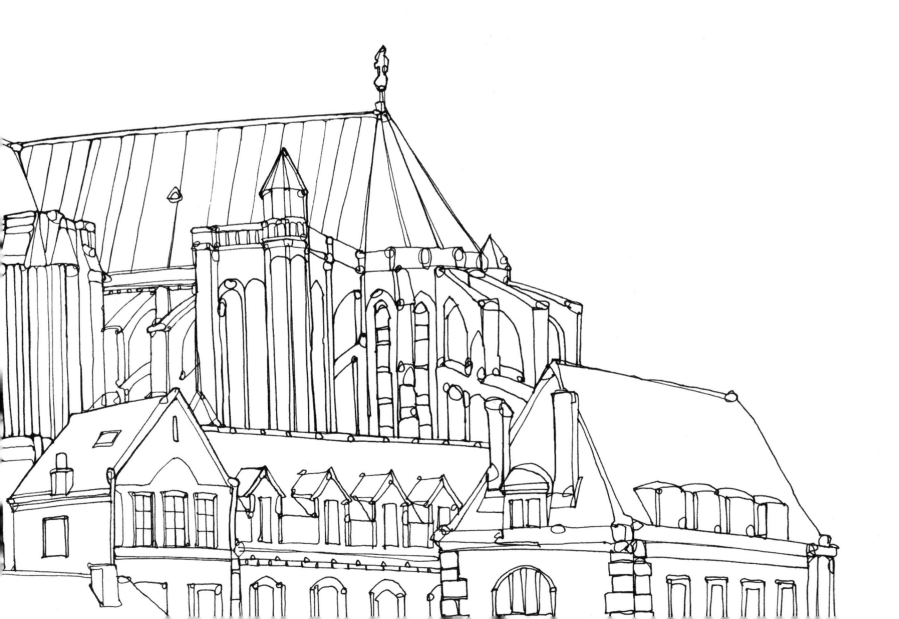

HAGIA SOPHIA
CE 537 | Istanbul, Turkey

In the early sixth century, the Byzantine emperor Justinian I ordered the construction of the Hagia Sophia on the site of an older church. Located in the heart of Istanbul, the magnificent building functioned as a Christian cathedral for the next 900 years. When the Ottoman Turks took Istanbul (then Constantinople) in 1453, however, the Hagia Sophia was converted into a mosque, minarets were added, and the Christian iconography was removed. Today it is a museum, where religious artifacts of both Christianity and Islam live side by side.

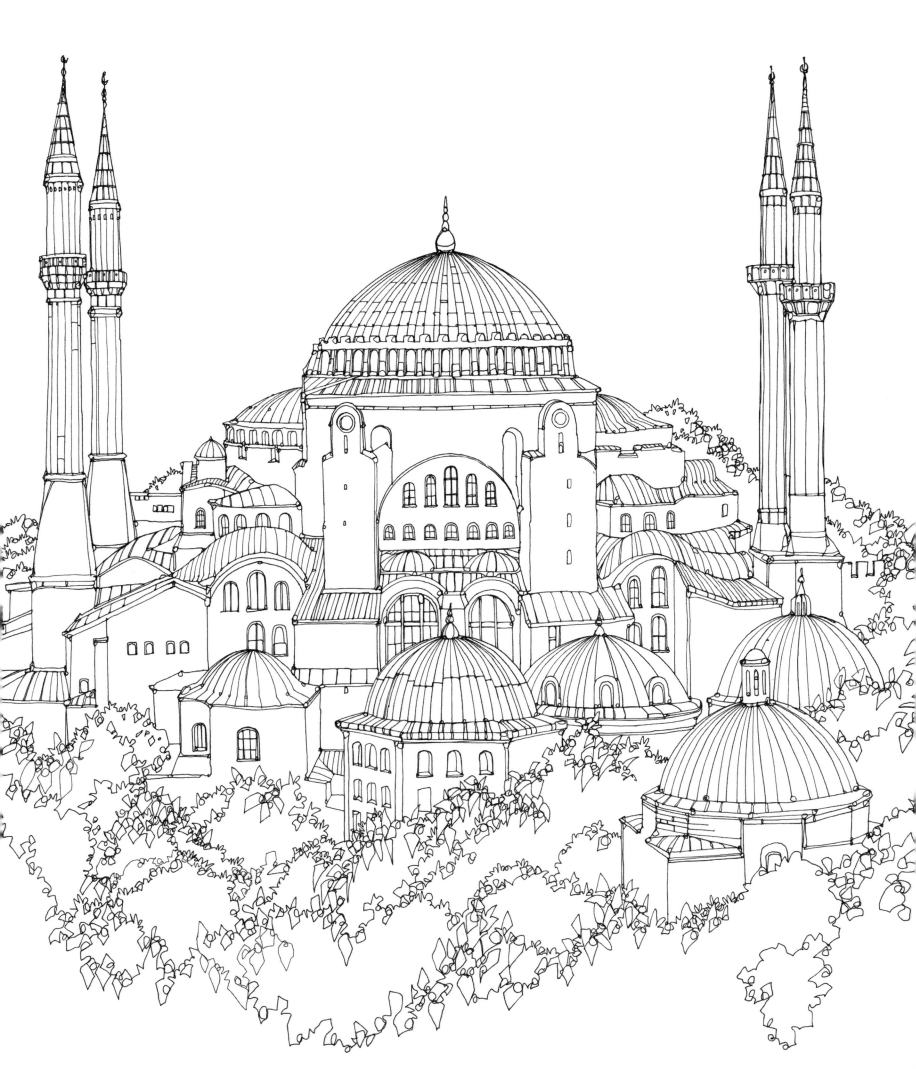

Dome of the Rock
CE 691 | Jerusalem, Israel

Situated on the holy Temple Mount site in the old city of Jerusalem, the Dome of the Rock holds at its core the Foundation Stone, making the shrine one of the most symbolic holy sites in Judaism, Christianity, and Islam. In Judaism, the stone marks the location of the Ark of the Covenant, and is mentioned in the Bible as the place of Abraham's sacrifice and the divine intersection between heaven and Earth. Islam holds it to be the point of Muhammad's ascension to heaven during his Night Journey. The Dome of the Rock is one of the oldest known examples of Islamic architecture and its octagonal walls are adorned with intricate, blue-green geometric mosaics, while the sparkling dome above is covered in 175 pounds (80 kg) of real gold.

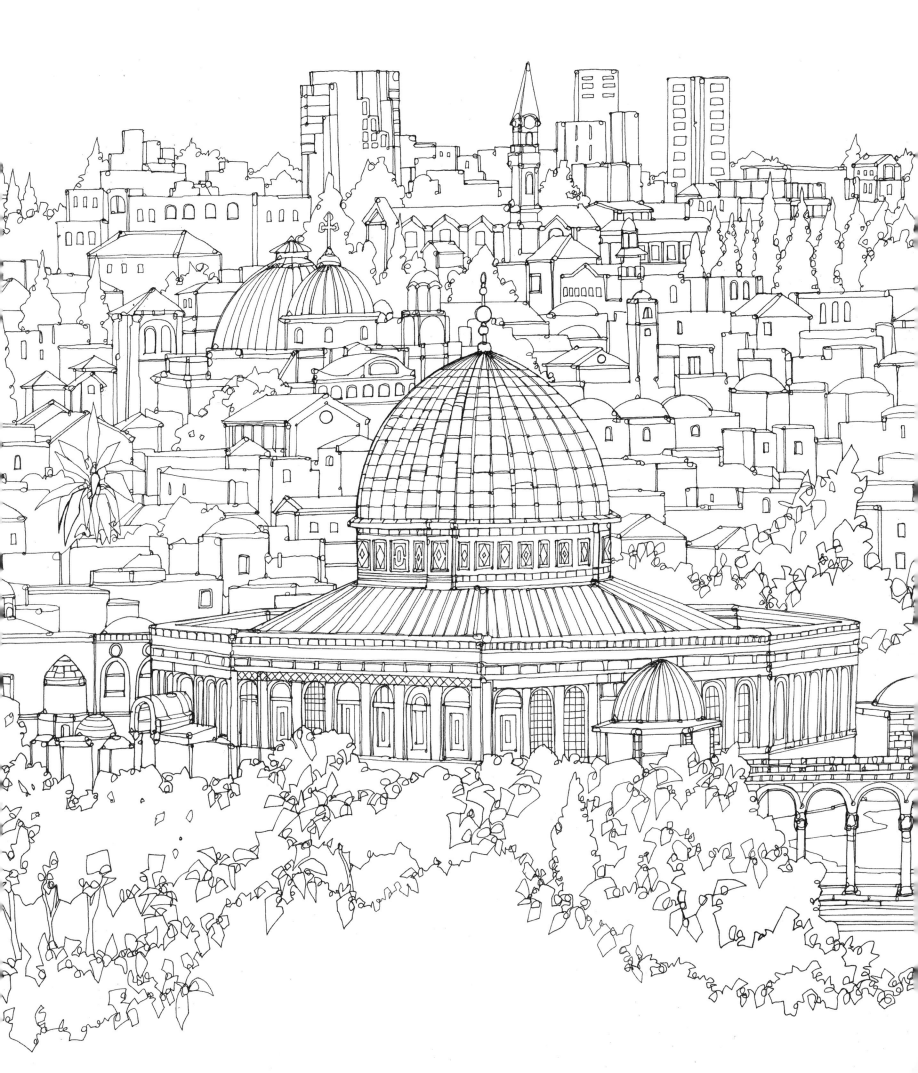

Saint Mark's Basilica
1093 | Venice, Italy

Often cited as one of the best examples of Byzantine architecture in the world, Saint Mark's Basilica is the most striking of the many churches in Venice. Its façade incorporates two sets of five arches, with columns in the lower third and Gothic tracery adorning the upper arches. The Venetians call it the "church of gold" because of the multitude of gleaming colorful mosaics covering many surfaces both inside and out. The most significant relics housed within Saint Mark's are the supposed remains of Mark the Evangelist, pilfered from Alexandria, Egypt, by two Venetian traders with the intention of bringing the Basilica significance as a holy site.

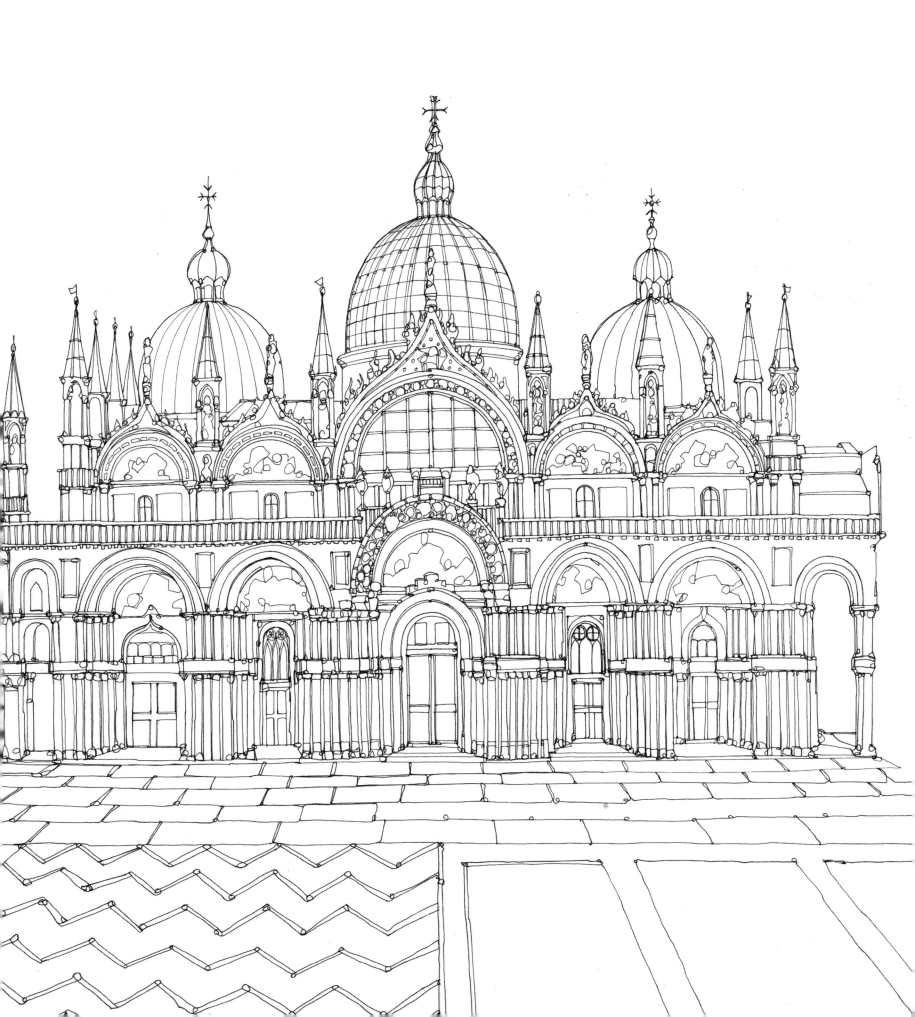

ANGKOR WAT
12th century | Cambodia

Angkor was once the capital of the ancient Kingdom of Khmer, which stretched across the entire Mekong Valley of Southeast Asia. At its heart is the great temple of Angkor Wat, one of the largest religious sites in the world, made up of a vast complex of smaller temples as well as a network of reservoirs, canals, and inhabited villages. Built from sandstone, the buildings of the complex are adorned with outstanding and intricate stone carvings and are striking examples of classical Khmer architecture. The towers in the center represent mountain peaks rising to the heavens and are surrounded by a moat that symbolizes the sea.

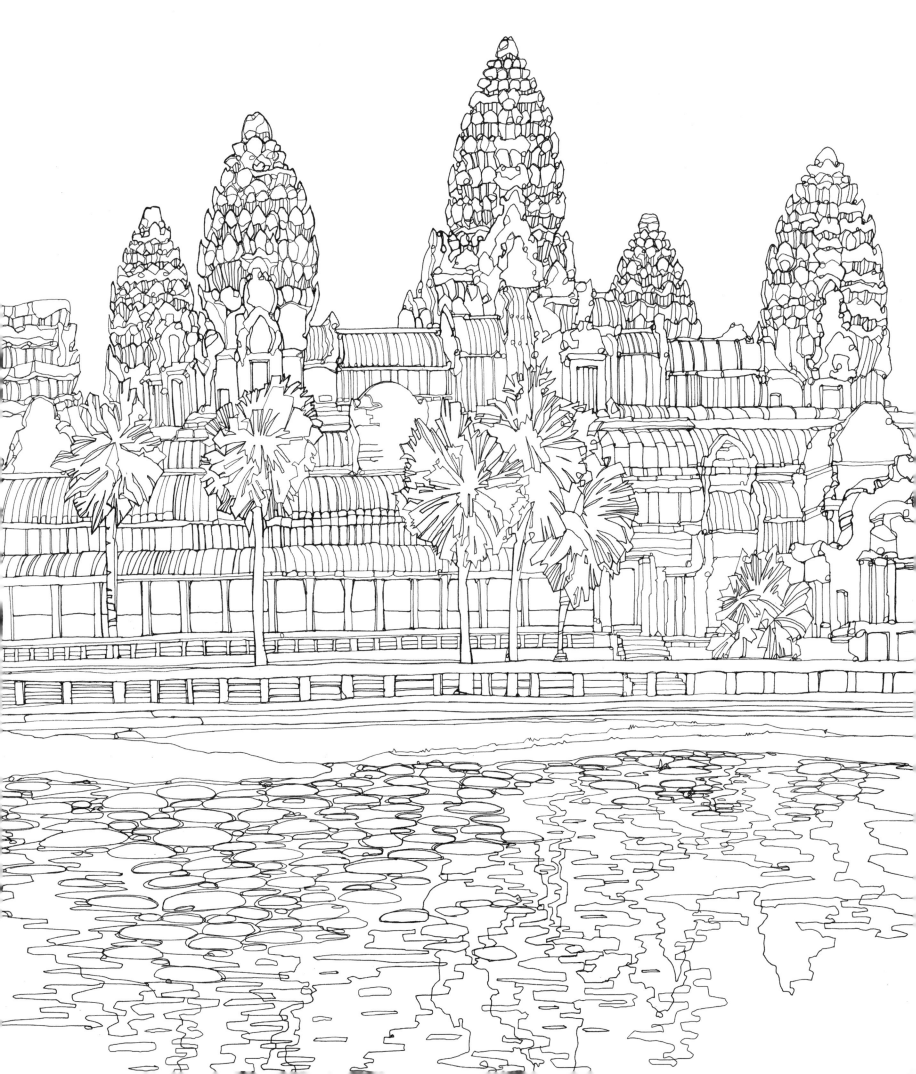

Chartres Cathedral
1220 | France

The cathedral at Chartres, about 50 miles (80 km) outside Paris, is the epitome of French Gothic architecture and remains in a remarkable state of preservation. Particularly notable are its impressive flying buttresses, typical of the Gothic tradition, as well as two mismatched spires in quite different architectural styles, and three wonderfully ornate rose windows that spill multicolored light into the vast interior. Chartres has been a key pilgrimage destination since the early Middle Ages and houses the supposed relic of the tunic of the Virgin Mary.

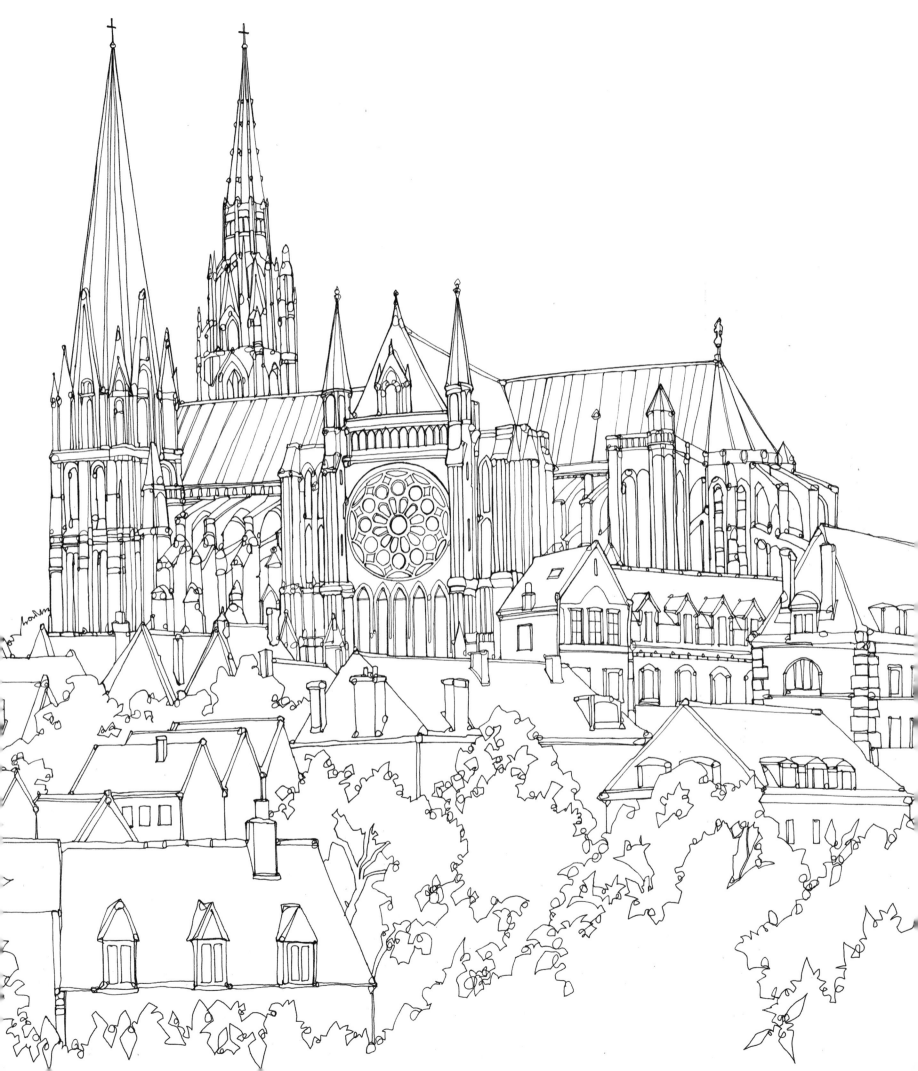

HEDDAL STAVKIRKJE
1242 | NORWAY

This towering wooden cathedral is the largest and finest of Norway's existing stave churches (stave churches are so named because of their construction from upright planks, or *stav* as they are called in Norwegian). This fairytale marvel is still the main church in the village of Heddal and services are held there regularly. It fell into disrepair over the years and was subject to a grand restoration project in the 1950s that returned it to its former glory. Built from Norwegian pine, the church stands on twelve support pillars, each bearing a fearsome carved face to ward off evil spirits.

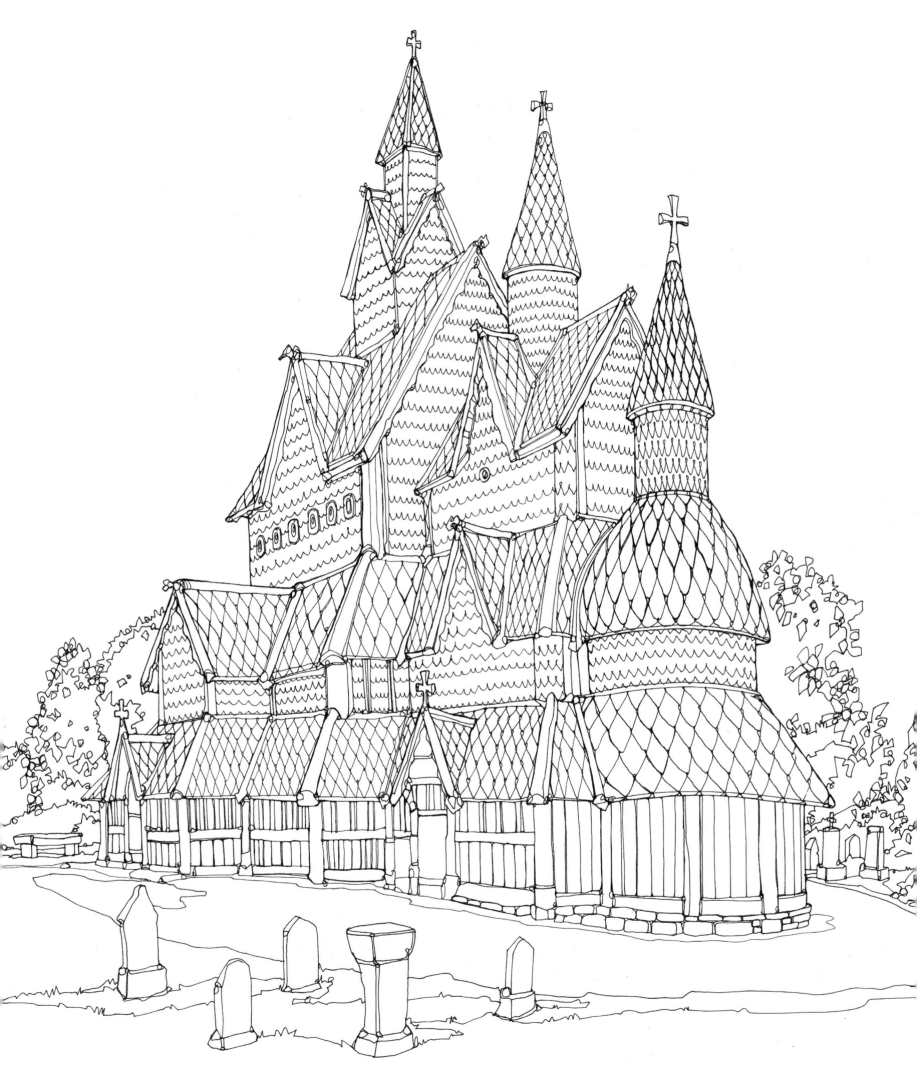

ALHAMBRA
1333 | Granada, Spain

The great palace-fortress complex of the Alhambra was originally a small citadel; the first mention of it in historical records dates to the ninth century. The stunning and imposing form that survives today was largely constructed during the mid-thirteenth century by the Moorish ruler Mohammed ben Al-Ahmar. It was completed and designated as a royal palace in 1333 by Yusuf I, Sultan of Granada. Catholics conquered Granada in 1492 and parts of the sprawling structure were put to use by Christian rulers. The buildings fell into disrepair over the centuries until the Alhambra was largely "rediscovered" by scholars in the nineteenth century. It is now recognized as housing some of the most significant examples of Islamic architecture in Spain.

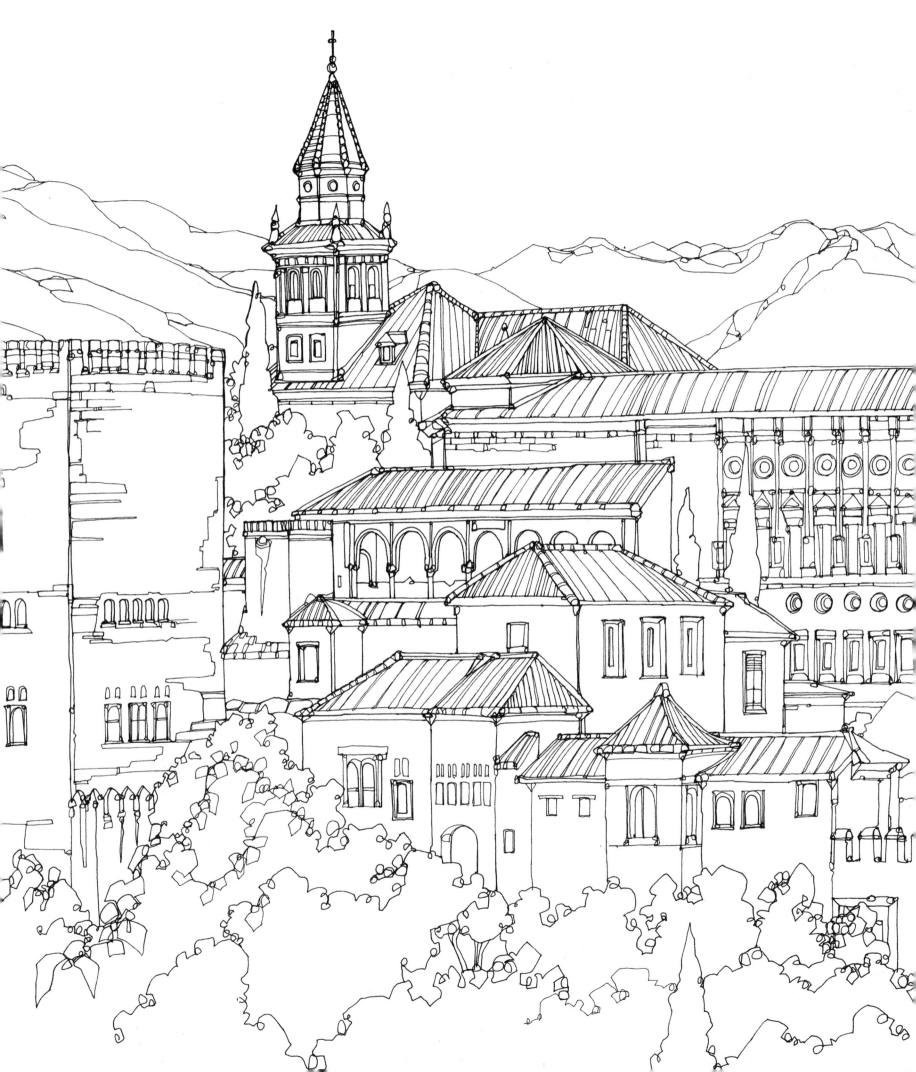

KINKAKU-JI
1397 | Kyoto, Japan

Kinkaku-ji, or the "golden pavilion," is situated in northern Kyoto. Formally known as Rokuon-ji, the "deer garden temple," it was the retirement home of the shogun Ashikaga Yoshimitsu. Before he died in 1408 he requested that his son transform the building into a Buddhist temple. Each floor is designed in a different architectural style, and the upper two floors are completely covered in gold leaf. The interior of the top floor is also covered in gold leaf and a golden phoenix perches on the roof. The current building was heavily restored following a terrible fire in the 1950s.

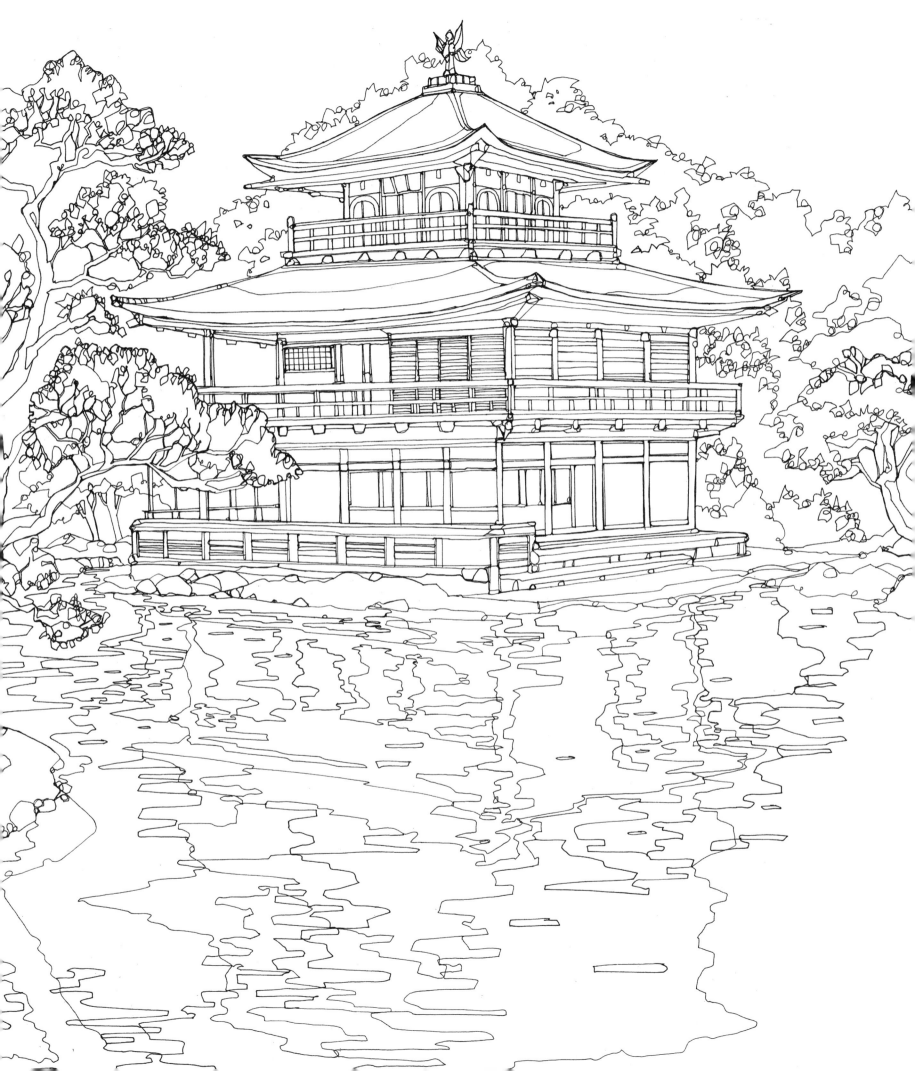

Prague Orloj
1410 | Czech Republic

The Orloj is a medieval astronomical clock (a special kind of clock
that displays the relative positions of astronomical bodies such as the sun,
moon, and planets, as well as the time). Installed on the wall of Prague's
Old Town Hall, it was built in 1410 by Mikuláš of Kadan, the Imperial
clockmaker, and Jan Šindel, a mathematics and astronomy professor. The
clock face is incredibly detailed, giving "Old Bohemian" and Babylonian
time, as well as central European time. When the clock strikes the hour, a
procession of mechanized figures perform the "Walk of the Apostles," in
which the Apostles (each can be recognized by his attribute) appear in turn
at the windows above the clock face.

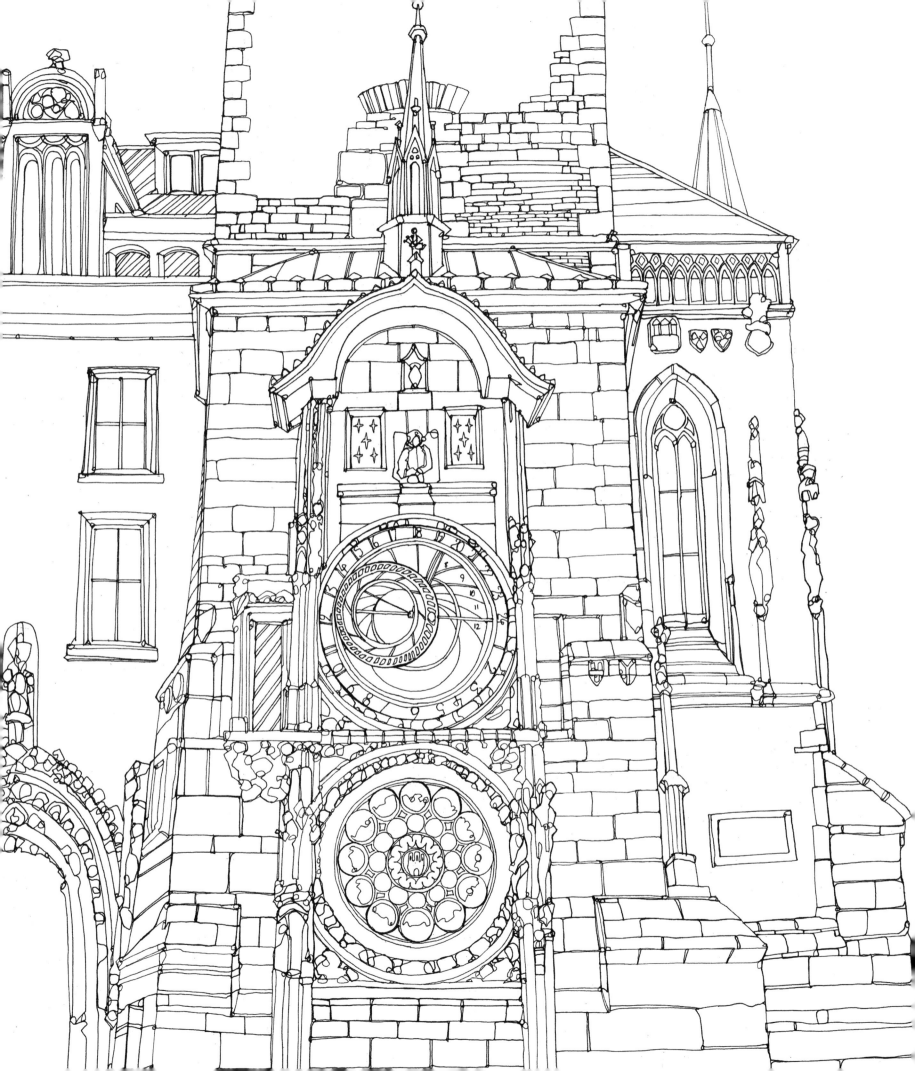

FORBIDDEN CITY
1420 | Beijing, China

The Forbidden City is a vast complex consisting of hundreds of structures, and within them thousands of rooms, or chambers. The central building, the Imperial Palace of the Ming and Qing Dynasties was, for centuries, the seat of the emperor. The complex is surrounded by a wall, moat, and ornamental gardens, and is celebrated for its key elements of traditional Chinese architecture, such as its yellow glazed roof with double eaves and its symmetrical design: it is built on an important central axis that is still the center of Beijing. It is believed to be the world's largest assemblage of ancient wooden structures still extant.

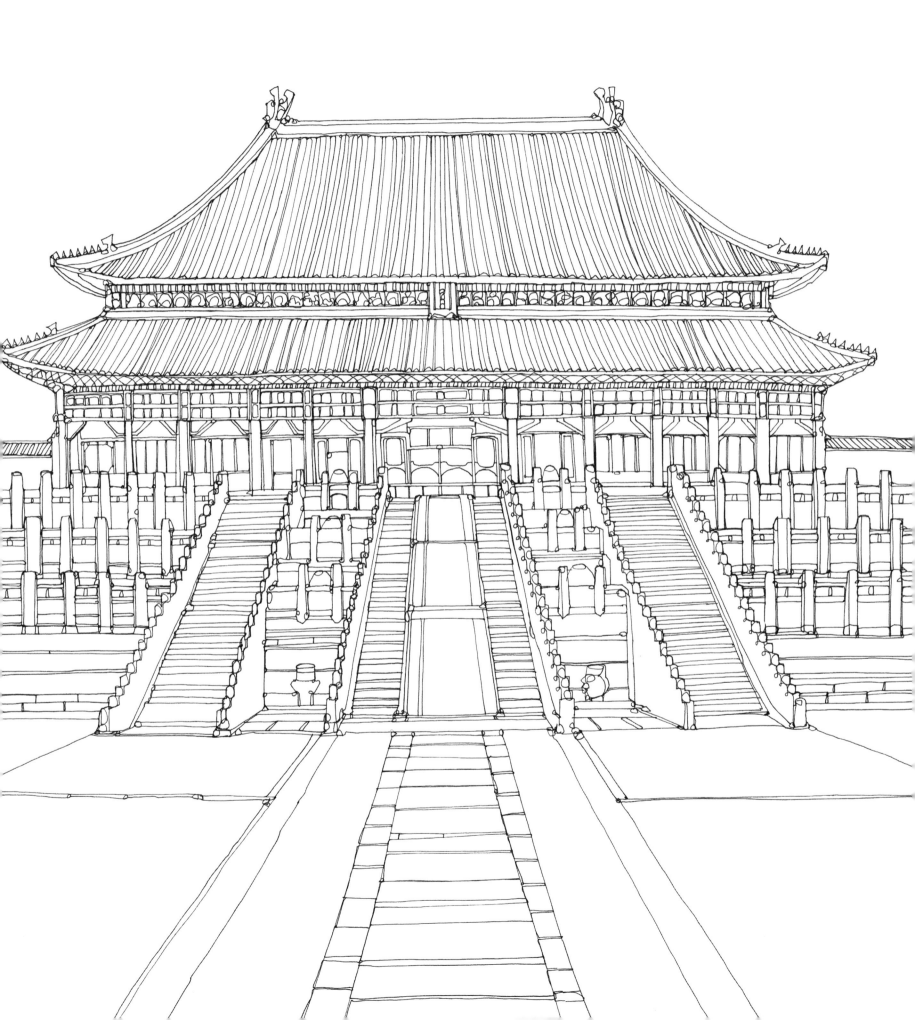

Duomo
1434 | Florence, Italy

This Roman Catholic cathedral is one of most enduring landmarks of
Florence. Construction began at the end of the thirteenth century by the
architect and sculptor Arnolfo di Cambio, but, after his death in 1310,
progress was slow. Over the ensuing century, numerous artists and
architects, including Giotto, worked on the building. Finally in the early
fifteenth century, Filippo Brunelleschi, a leading architect of the Italian
Renaissance, won a commission to design the distinctive dome. The
cathedral's façade remained unfinished up until the nineteenth century,
when architect Emilio De Fabris succeeded in bringing together
the Gothic and Renaissance style in a highly decorative design of red,
white, and green marble.

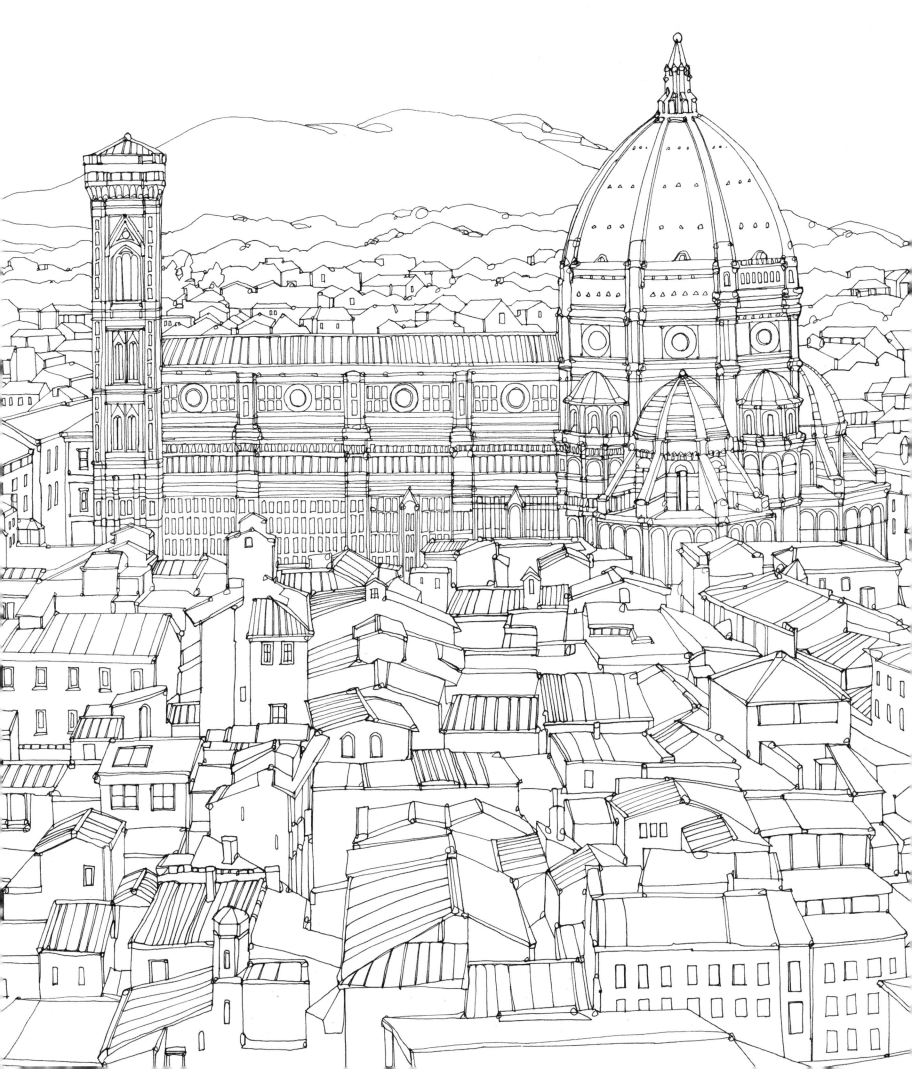

BLUE MOSQUE
1481 | Mazar-i-Sharif, Afghanistan

This stunning "Blue Mosque" stands resplendent at the heart of the Afghan city of Mazar-i-Sharif. Its many arches, minarets, and chambers are almost entirely covered with mosaic tiles in shades of blue or gold. Throughout the centuries, tombs of varying shapes and sizes have been added for Afghan rulers and religious leaders, giving it its multilayered outline. The mosque was restored in the mid-twentieth century and attracts Shia pilgrims throughout the year, especially during the celebration of New Year. The site is also known to many as the Shrine of Ali because it is believed that the remnants of Ali (the cousin of Muhammad) are buried in its core chamber.

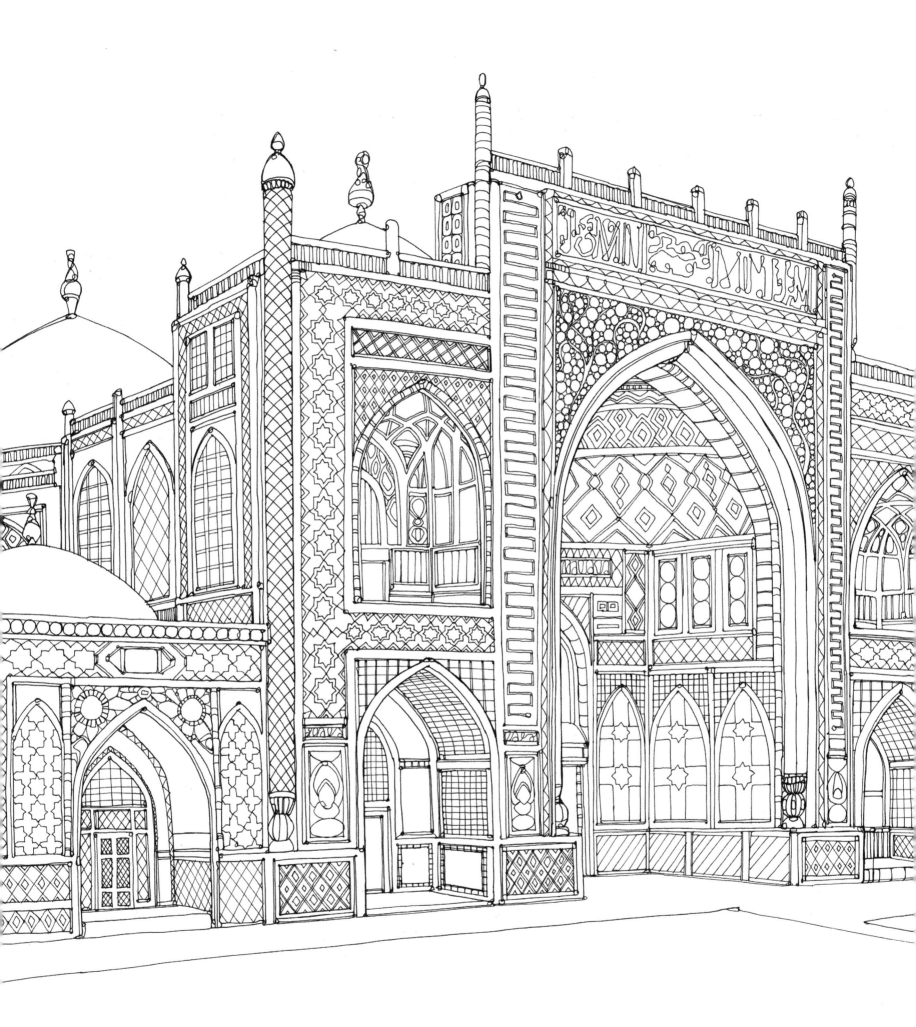

King's College Chapel
1515 | Cambridge, UK

King Henry VI founded King's College in Cambridge in 1441 as a destination for pupils of Eton College, a school he had founded the previous year. Construction was slow over the next century as the War of the Roses intervened and the king was deposed. The chapel was finally finished in 1515 and is widely seen as one of the greatest examples of late Gothic architecture, containing the world's largest fan-vaulted ceiling and twenty-six stained-glass windows. Overlooking the altar is Peter Paul Rubens's famous painting, *Adoration of the Magi* (1634). The chapel remains a place of worship for college scholars today and is home to the world-famous King's College choir.

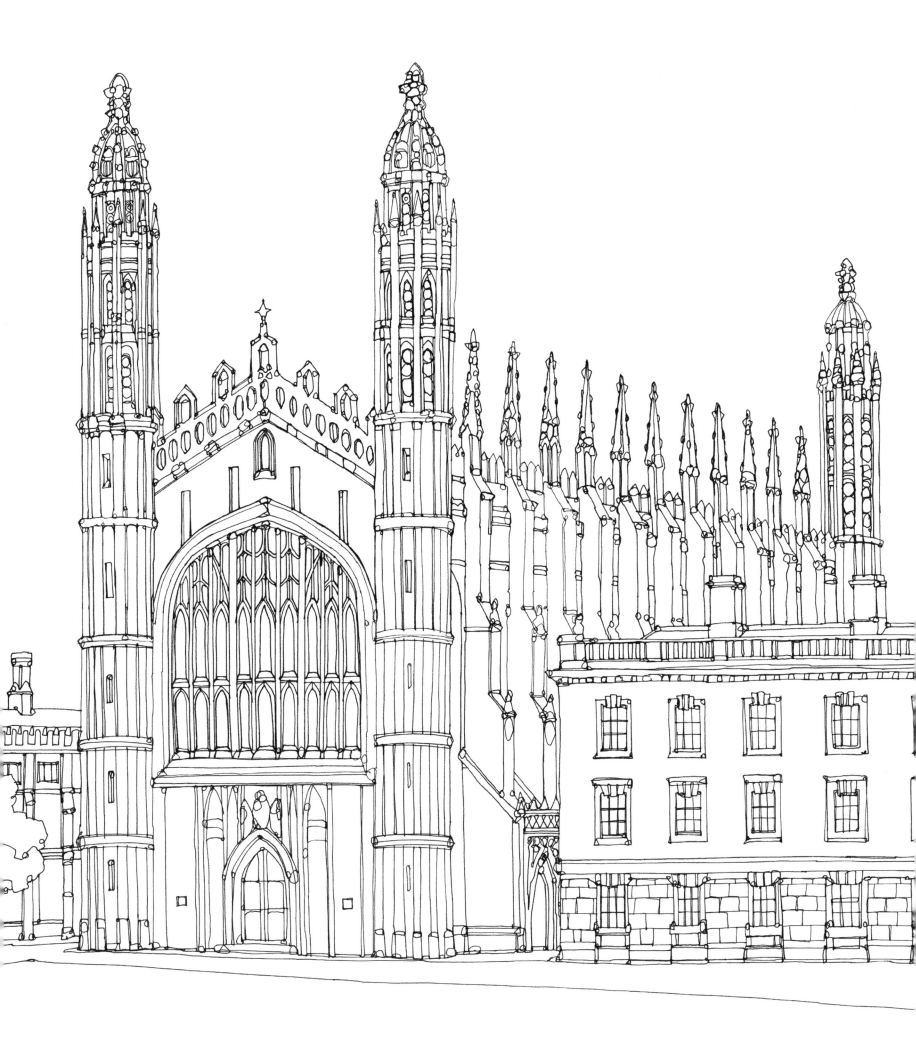

SAINT BASIL'S CATHEDRAL
1561 | Moscow, Russia

St. Basil's Cathedral is situated at the southern side of Red Square in Moscow and is today an enduring symbol of Russia. In 1552, Ivan the Terrible captured the valuable port of Kazan and ordered the church to be built to commemorate the victory. Despite its exaggerated shapes and bright colors, the cathedral forms a coherent plan of nine main chapels. The tall, tent-roofed structure in the center houses the main chapel, the four biggest onion domes sit atop four octagonal-towered chapels, and four smaller chapels nestle in between. According to folklore, Ivan had his architects blinded so that they could never create anything as beautiful ever again.

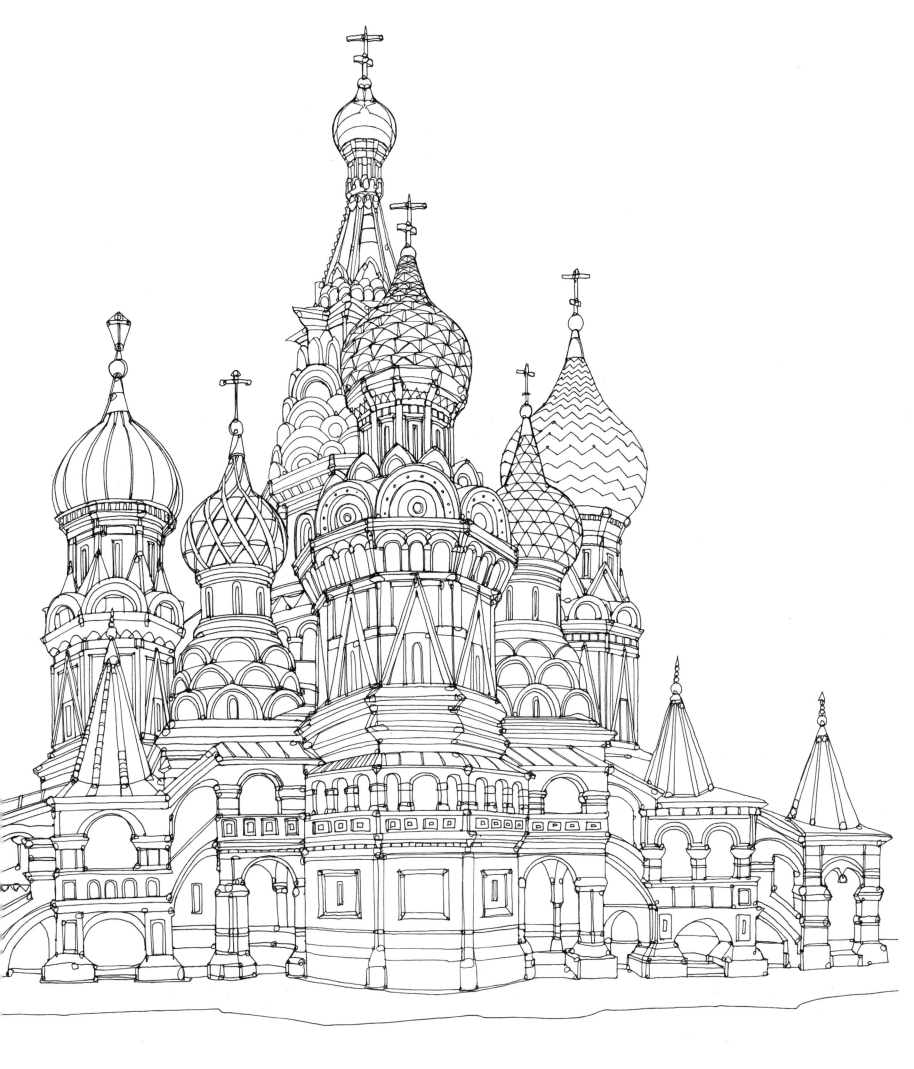

BEN YOUSSEF MADRASSA
1565 | Marrakesh, Morocco

The Ben Youssef Madrassa was built as an Islamic college. It was originally founded by the Marinid sultan Abu al-Hasan, but rebuilt in the 1560s under the later Saadian dynasty. Once home to more than eight hundred students, it is now no longer a theological college and open to the pubic as a historical site. An engraving above the door reads "You who enter my door, may your highest hopes be exceeded," and visitors can take this at its word: Inside is a central courtyard leading to a prayer hall where every single surface is decorated with carved wood, stuccowork, or mosaic tile work exquisitely depicting detailed inscriptions and geometric patterns.

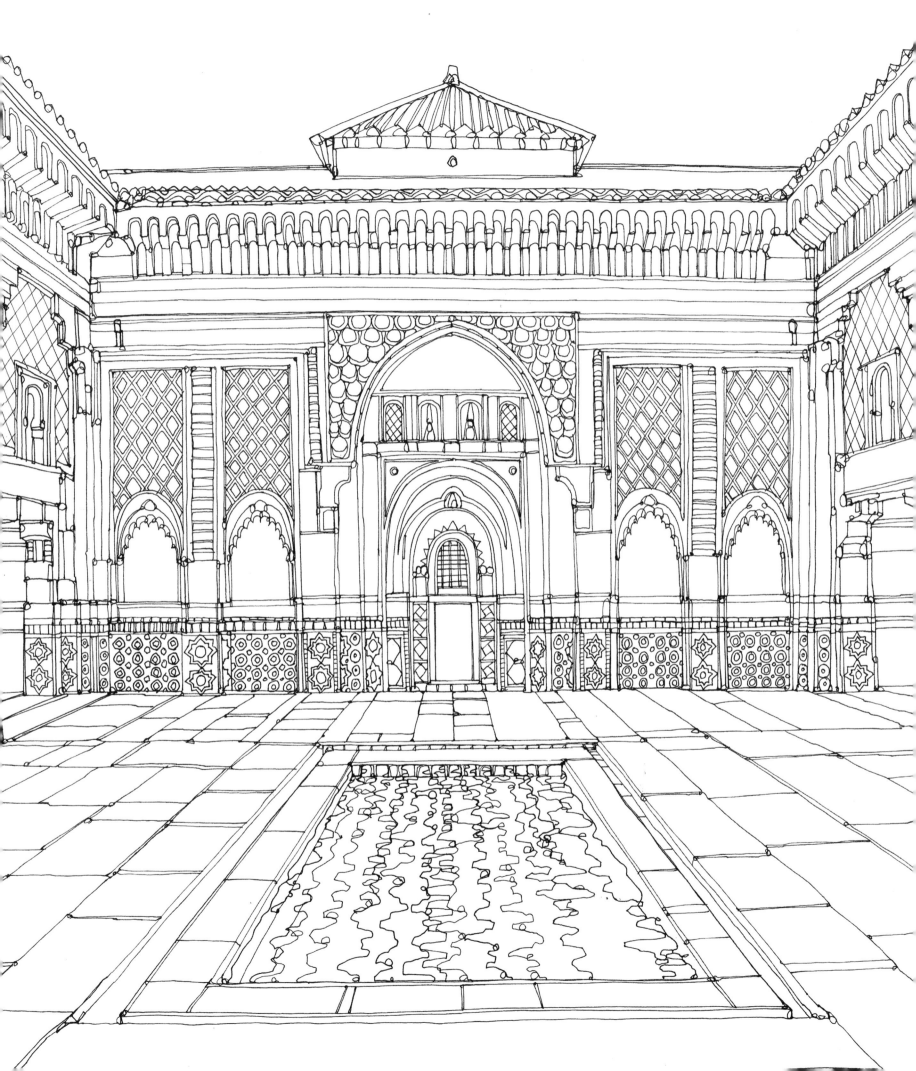

GOLDEN TEMPLE
1604 | Amritsar, India

The Harmandir Sahib (meaning "Temple of God," and more commonly known as the Golden Temple) is a Sikh place of worship in Amritsar, northwest India. The gilded temple is surrounded by a pool of holy water and almost seems ablaze when its gilded surfaces are captured in the evening sunlight. It has four doors, open on each side, demonstrating that the Sikhs welcome people of all faiths to worship within. Despite its magnificent appearance, it was purposefully built at lower than ground level to embody humility. The temple houses the Guru Granth Sahib, the sacred holy text of the Sikhs. It is also home to the Langar, a community canteen where all people can eat together as equals.

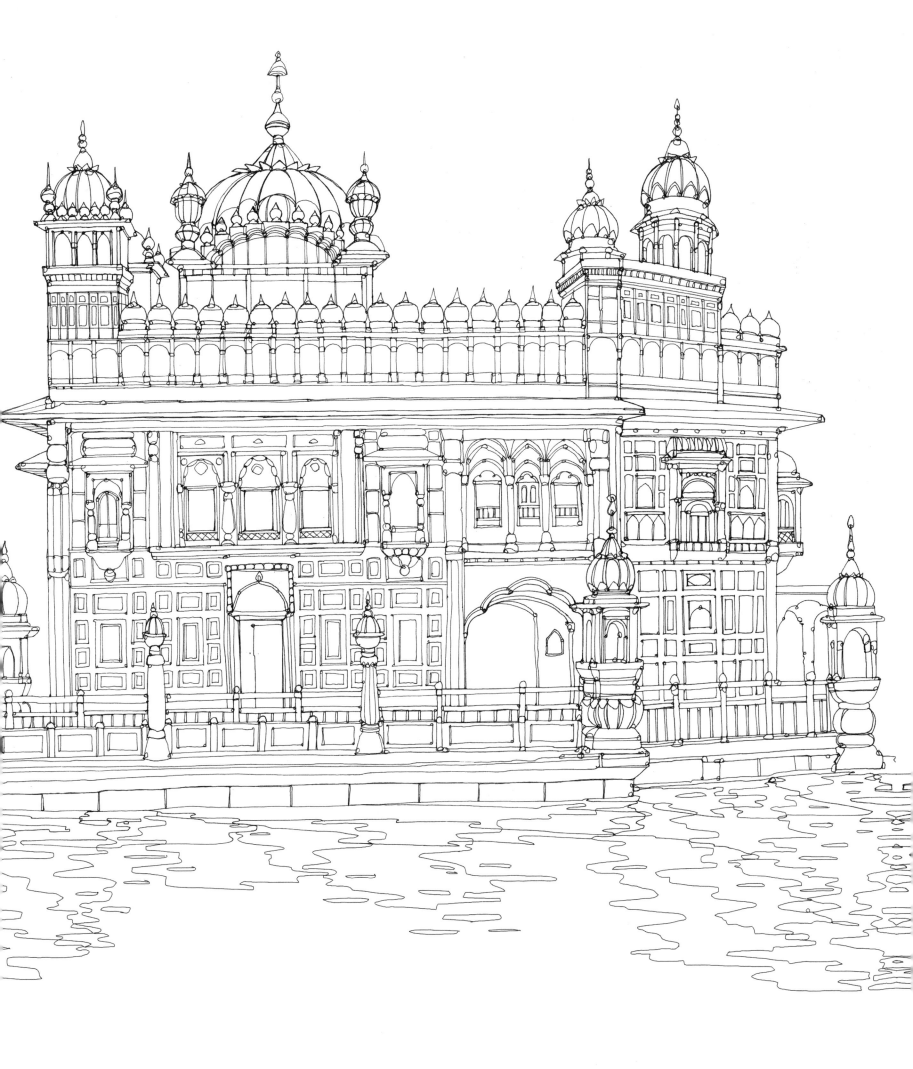

GREAT SYNAGOGUE
1859 | Budapest, Hungary

The Great Synagogue, or Dohány Street Synagogue, lies in Erzsébetváros, the seventh district of Budapest, and was designed by architect Ludwig Förster. With nearly 3,000 seats, it is the second-largest synagogue in the world and the main place of worship for the Jewish communities of central Europe. Its style is Moorish-Byzantine, with two octagonal towers and a large stained-glass rose window above the main entrance. During World War II, German occupiers used the synagogue as a stable. Today the site now also encompasses the Hungarian Jewish Museum and a Jewish cemetery where over 2,000 victims who died in the Jewish ghetto during the winter of 1944–45 are buried.

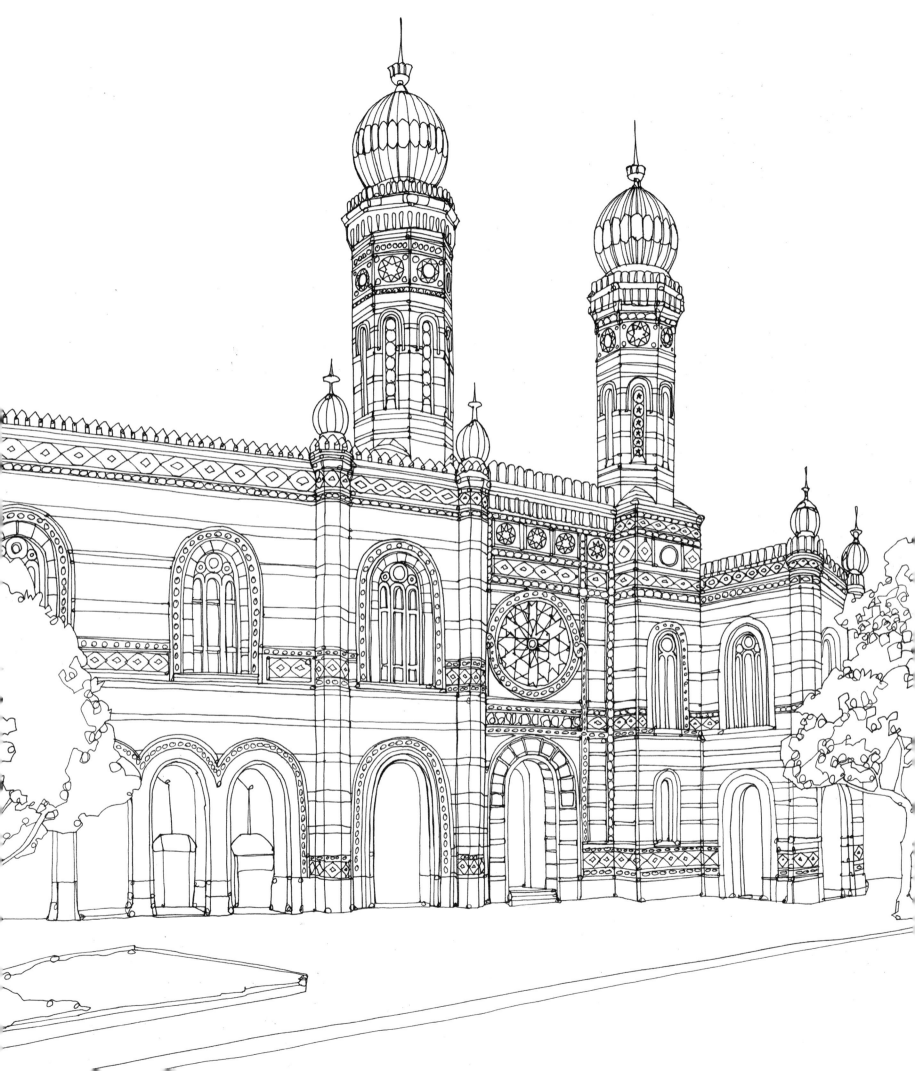

U.S. Capitol
1863 | Washington, DC, USA

The U.S. Capitol is the seat of the U.S. Congress, the legislative branch of the American government. Architect William Thornton won a competition to design the building in 1793 and Congress met onsite for the first time in 1800, when only the north wing was completed. The striking neoclassical building is made of brick and clad in sandstone and marble, while the dome (added in the 1850s and topped with the Statue of Freedom in 1863) is made entirely of cast iron. The Capitol has remained in near-continuous use as the meeting place of the nation's legislature for more than two-hundred years, and is also visited by millions of tourists each year.

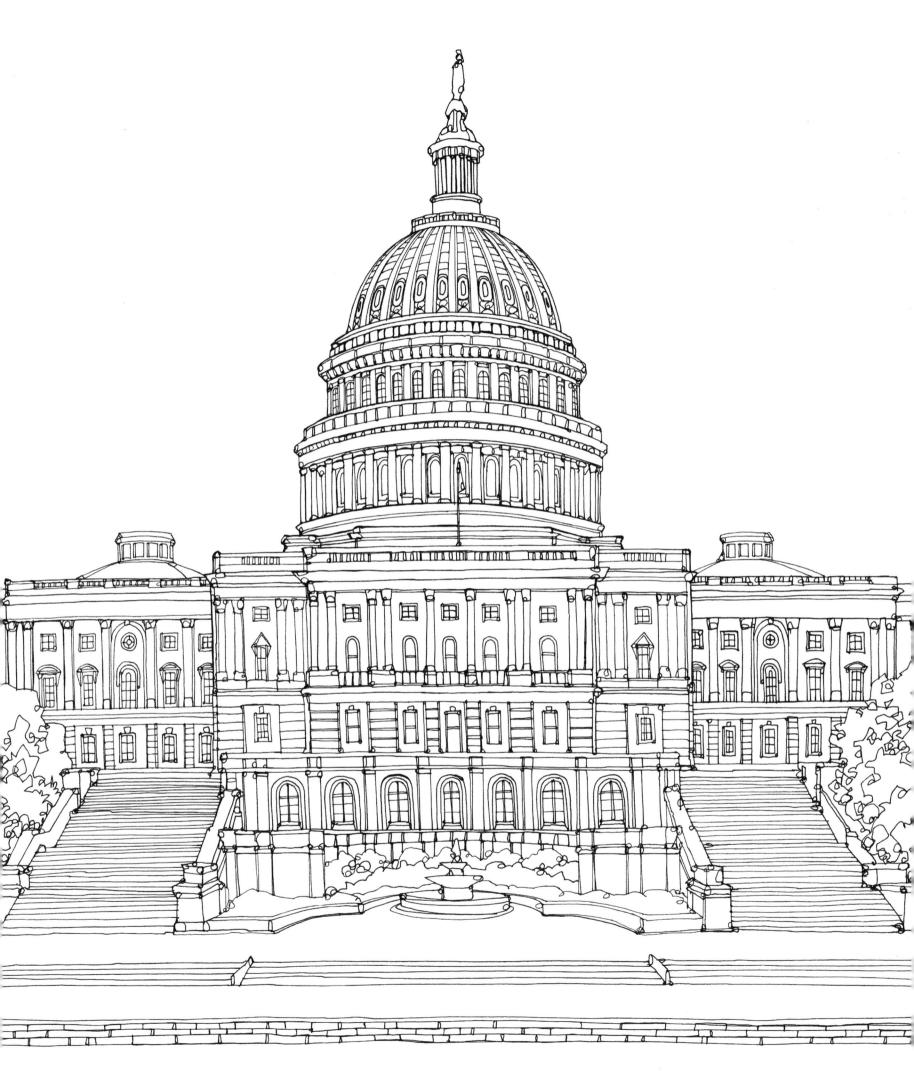

PALACE OF WESTMINSTER
1870 | London, UK

The Palace of Westminster, an important example of neo-Gothic architecture, sits grandly on the north bank of the Thames in London. The current structure, referred to as the "New Palace," was built between 1840 and 1870 and encompasses all that remains of the medieval "Old Palace" that burned down in 1834. Its last royal resident was Henry VIII (1491–1547) before the lawyers and politicians moved in and its role as a center for law and governance was cemented. The Palace of Westminster still currently functions as the seat of the British Parliament. The clock tower housing the world-renowned Big Ben bell was completed in 1858 and remains an enduring symbol of London.

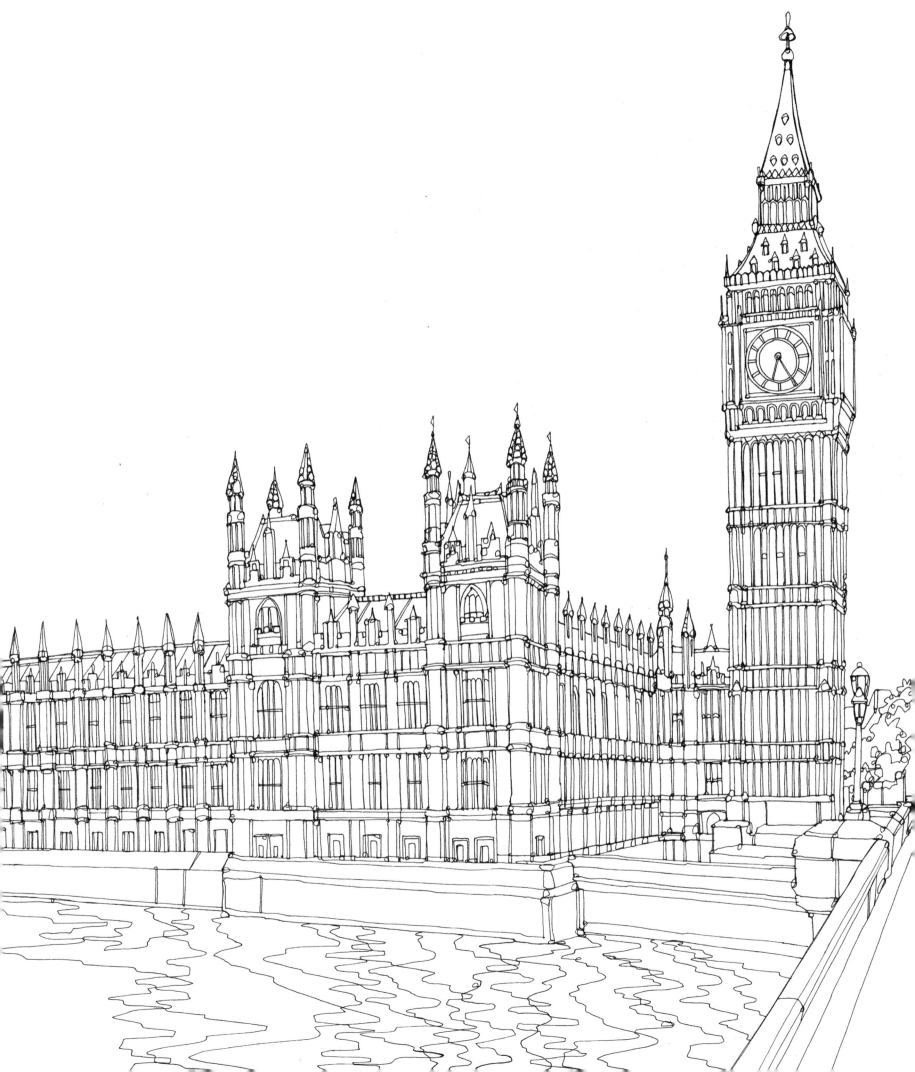

La Sagrada Família
1882 (groundbreaking) | Barcelona, Spain

La Sagrada Família is a soaring cathedral rising out of the bustling heart of Barcelona. Its architect, Antoni Gaudí, intended the structure to be a "cathedral for the poor." He was appointed chief architect in 1883, but died in 1926 when he was hit by a tram just a few streets away from the cathedral-in-progress, to which he had almost completely dedicated the latter years of his life. Completely untraditional, magical, and extremely tall—the spires reach 560 feet (170 m)—the Sagrada Família was viewed as controversial by many. In 1936 during the Spanish Civil War, revolutionaries broke in and started a fire that destroyed Gaudí's original plans, models, and drawings. The cathedral is still unfinished and has a projected completion date of 2026. It has now become the number-one tourist attraction in Barcelona, with around three million visitors a year.

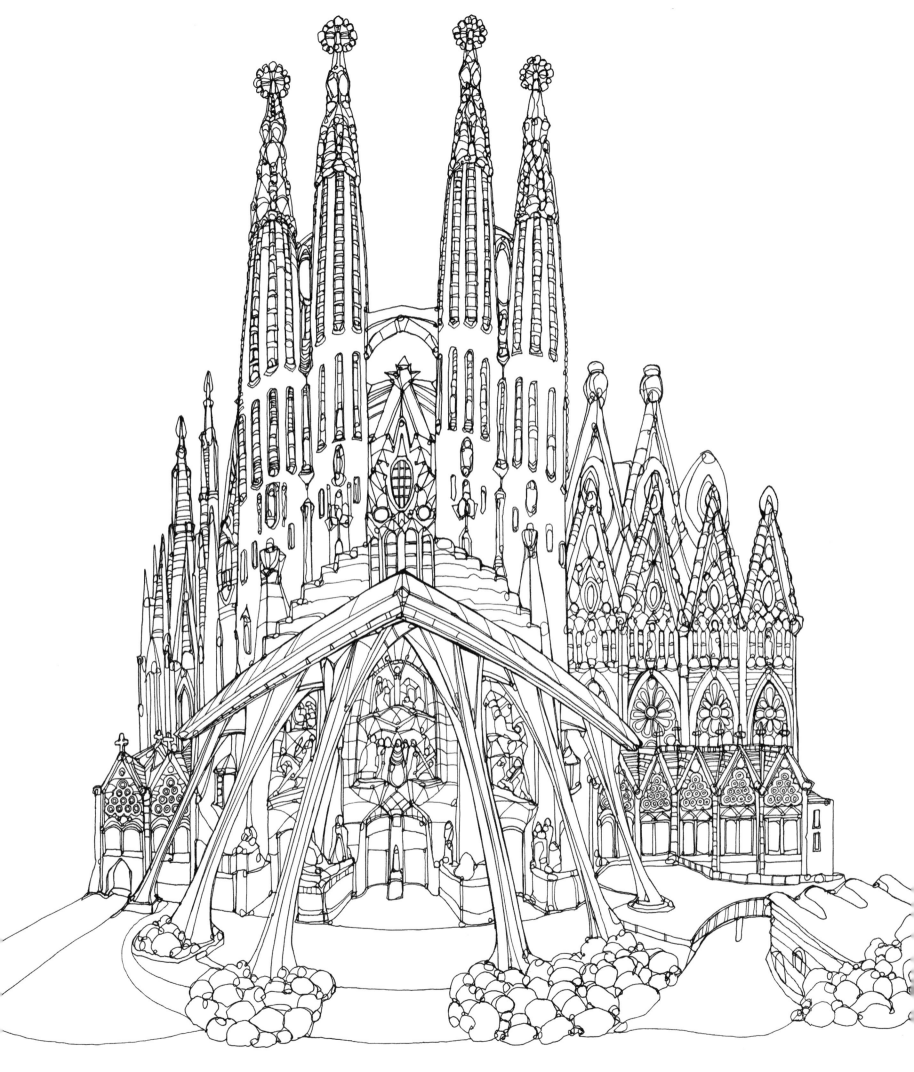

Rijksmuseum
1885 | Amsterdam, Netherlands

The Rijksmuseum, home to the Netherlands's national art collection, was originally established in The Hague, but moved to Amsterdam in 1808 and was housed in the Royal Palace on Dam Square. The current building, by architect Pierre Cuypers, was built in a neo-Renaissance style to properly display the world-famous works of art in the collection, such as Rembrandt's 1642 masterpiece *The Night Watch* (which had a specific hall built for it) and several paintings by Johannes Vermeer, Anthony van Dyck, and Jan Steen, among thousands of others. A major expansion was carried out in the twenty-first century and the expanded museum reopened in 2013.

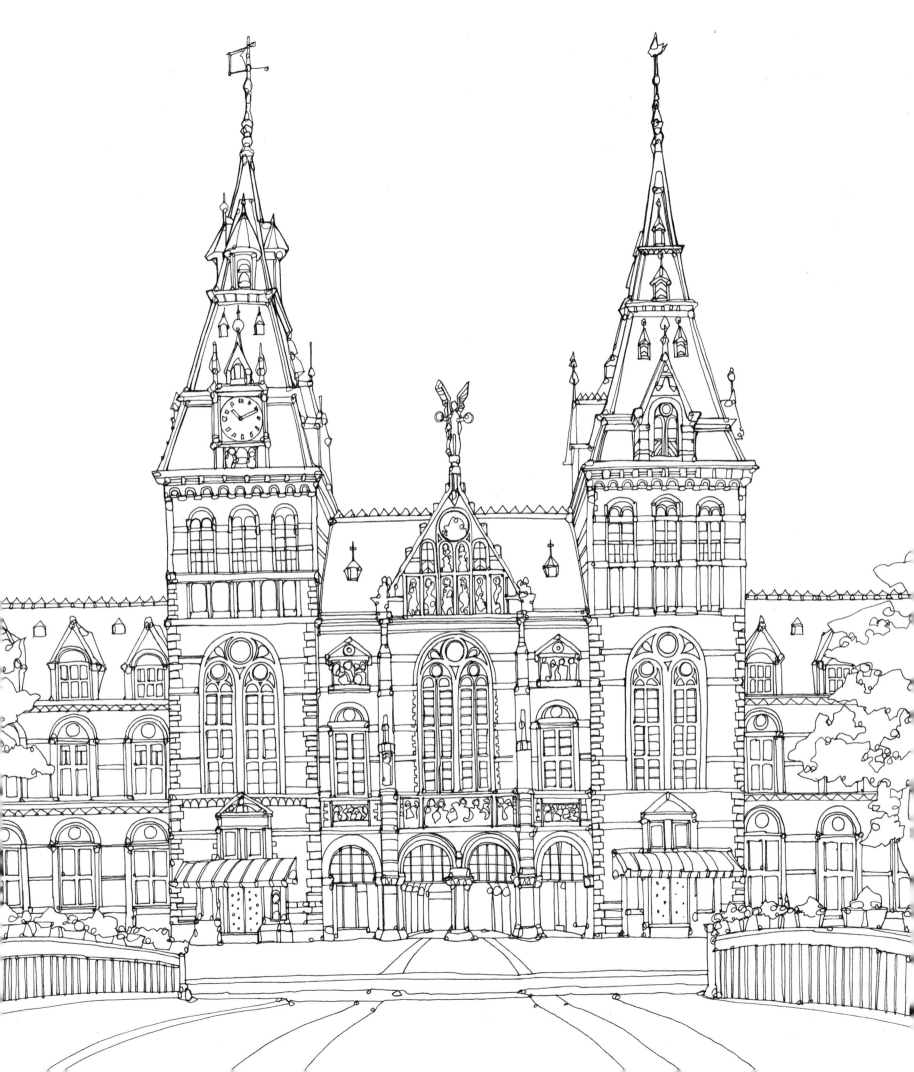

Neuschwanstein Castle
1892 | Hohenschwangau, Germany

Neuschwanstein is a fairy-tale palace on top of a hill in Hohenschwangau in southwest Bavaria. It was built as a refuge for King Ludwig II, a notoriously shy monarch who wanted to hide away from public life. The Romanesque revival design was drafted by a theatrical stage designer and realized by architect Eduard Riedel. Sadly Ludwig died before the castle was finished, and it has been open as a visitor attraction ever since. The interior decoration was based on stories from the operas of Richard Wagner, Ludwig's favorite composer. A recurring motif in the decoration is the swan; the name "Neuschwanstein" literally translates as "new swan stone."

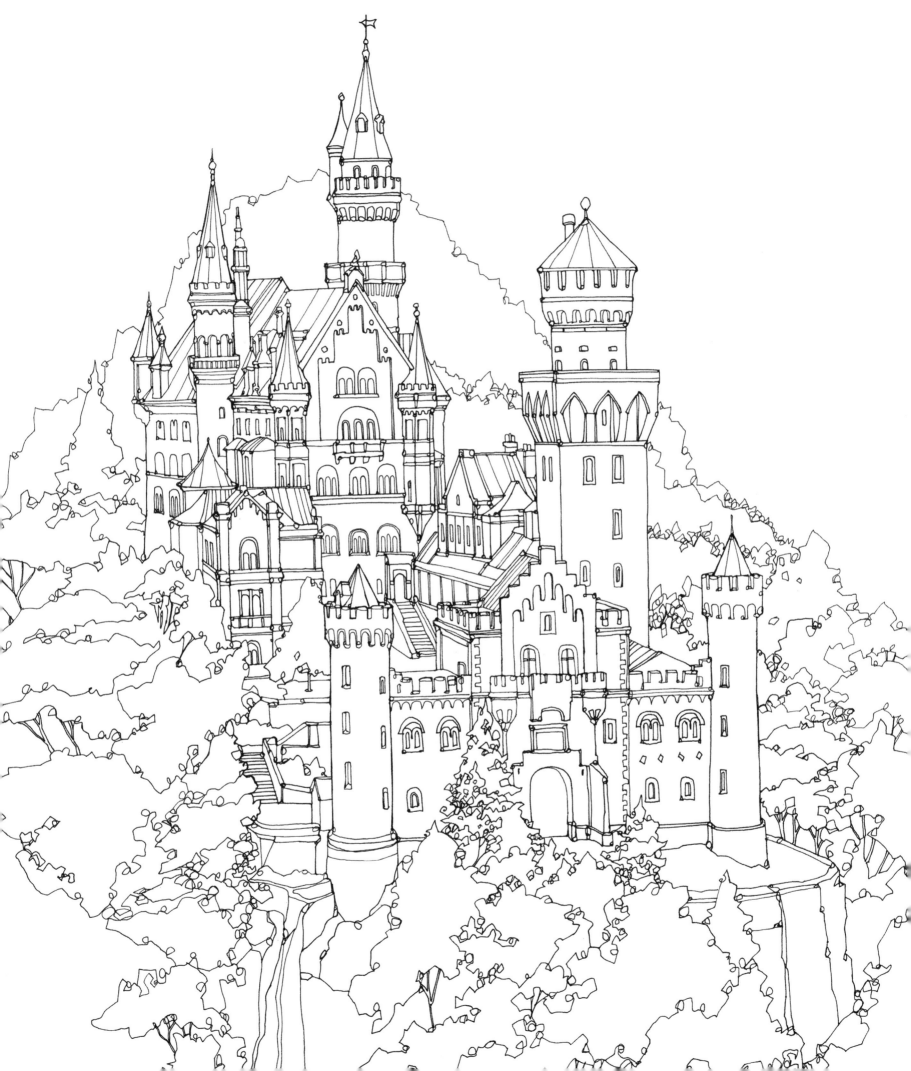

TOWER BRIDGE
1894 | London, UK

Tower Bridge is an ornate Victorian bridge crossing the River Thames from the borough of Tower Hamlets in the north to Southwark on the southern bank. Increased commercial development during the Victorian period saw the need for more people to be able to cross the river as well as travel on it by boat at the same time. Architect Horace Jones and engineer John Wolfe Barry came up with an ingenious solution of part drawbridge and part suspension bridge. The high-level walkways at the top allowed foot traffic to continue while the drawbridge below allowed boats to pass underneath. The drawbridge was operated by a complex steam-powered hydraulic system and only took a minute to open fully. Today it's powered by oil and electricity, and the walkways have been installed with glass floors to give visitors a bird's-eye view of the bridge and river below.

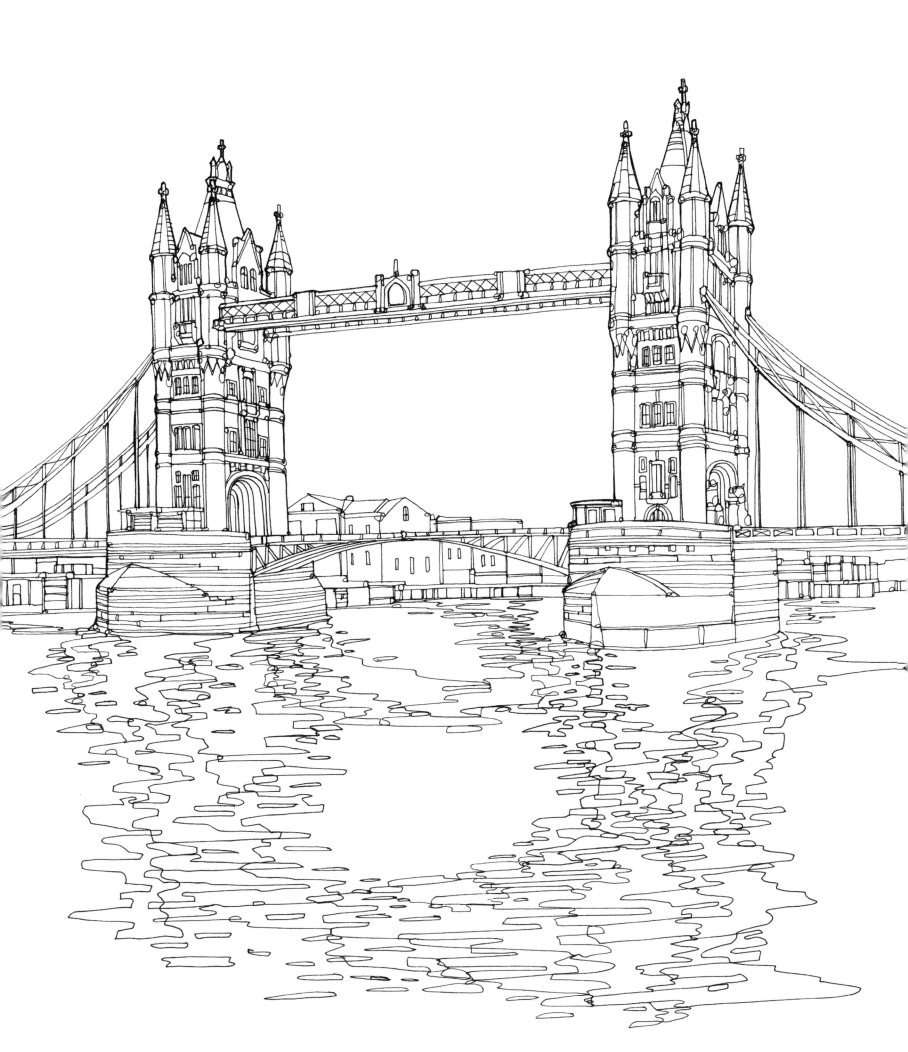

Teatro Amazonas
1896 | Manaus, Brazil

At first glance one might assume that this elegant opera house is located in a European capital, rather than in the middle of the Brazilian rain forest. Newly wealthy rubber plantation owners in Manaus funded the building, keen to emulate a sophisticated European lifestyle. The marble was sourced from Italy, the roof tiles from Alsace, and the steel from Scotland, while the dome was overlaid with 36,000 decorative ceramic tiles in the colors of the Brazilian flag. When it was discovered that rubber could be created artificially, however, the city lost its riches and the opera house sat abandoned for nearly ninety years. In 2001, the government decided to revive the building, and today it has become the center of a thriving music scene and film festival.

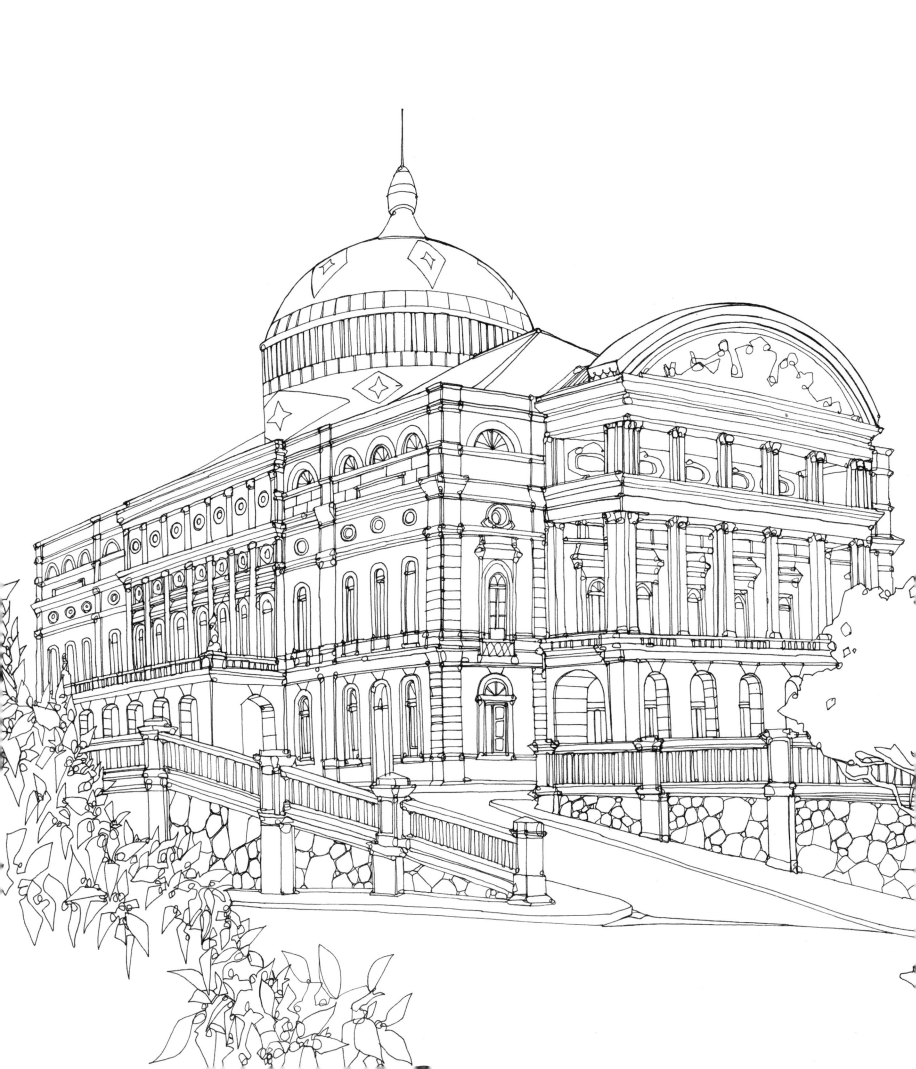

Palacio Barolo
1923 | Buenos Aires, Argentina

The Palacio Barolo is located in the Monserrat neighborhood of Buenos Aires, and was the brainchild of wealthy businessman and farmer Luis Barolo. This office building housed a host of different companies and acted as a flagship for Argentinean industry. The interior design for the building was inspired by Dante's epic poem the *Divine Comedy* and was divided into three sections; the basement and ground level represented hell, with purgatorial floors above them, and heaven occupying the very top. When first built, the 330-foot (100-m) building was the tallest in South America. Some say the light emitted from the lighthouse atop the building can be seen as far as Uruguay. The building is still used for its original purpose today, providing office space for a number of different Argentinean companies.

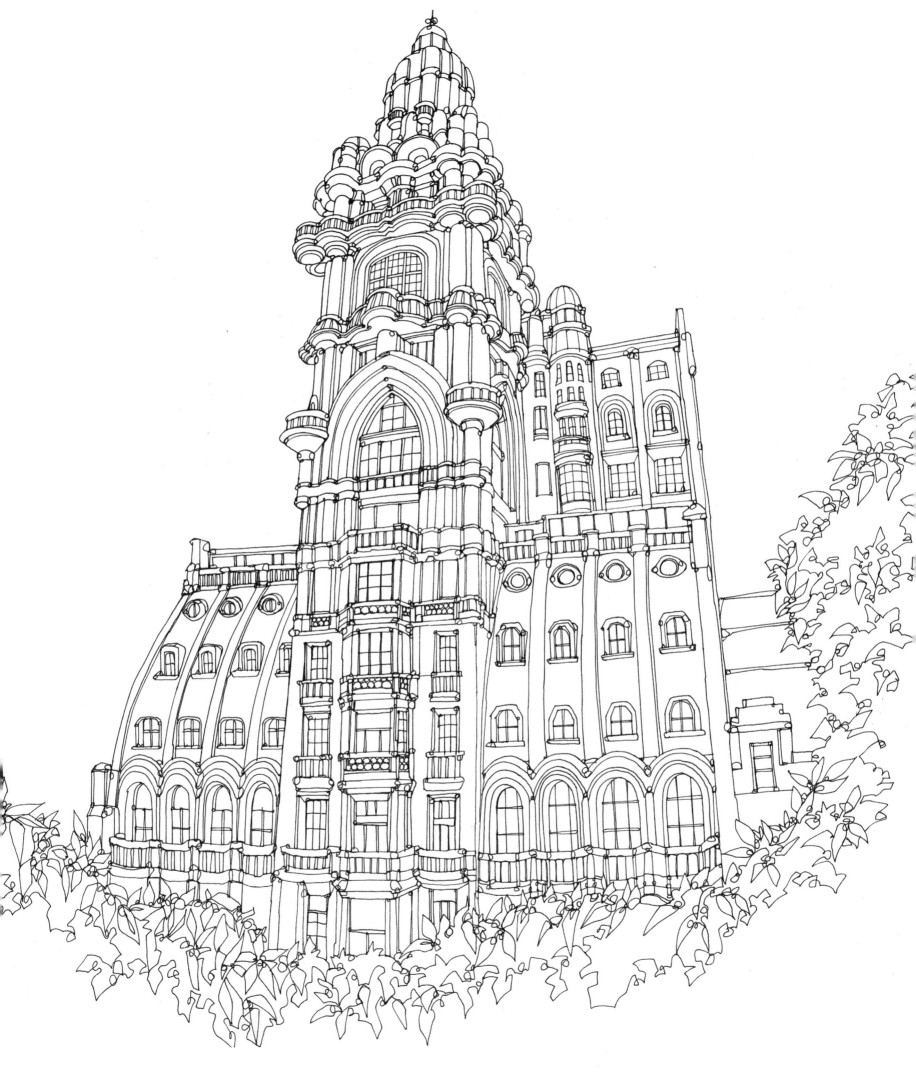

PARLIAMENT HILL
1927 | Ottawa, Canada

Parliament Hill is a collection of grand buildings on a limestone outcrop on the southern banks of the Ottawa River. When the new Province of Canada was created in 1841, Ottawa was chosen as the permanent capital and a home was needed for the new parliament. The first parliament building was completed in 1876, but largely destroyed by fire in 1916. The complex we see today dates to 1927. It was built by two teams of architects in a High Gothic style with vaulted ceilings and marble floors. The site consists of the Senate Chamber with its gold-leaf ceiling; the House of Commons (with walls made from limestone that contains 450-million-year-old fossils); the Library with its hundreds of wood carvings; the Centre block, which allows visitors to watch a sitting of parliament; and finally the 300-foot (92-m) Peace Tower, which includes fifty-three bells and an observation platform.

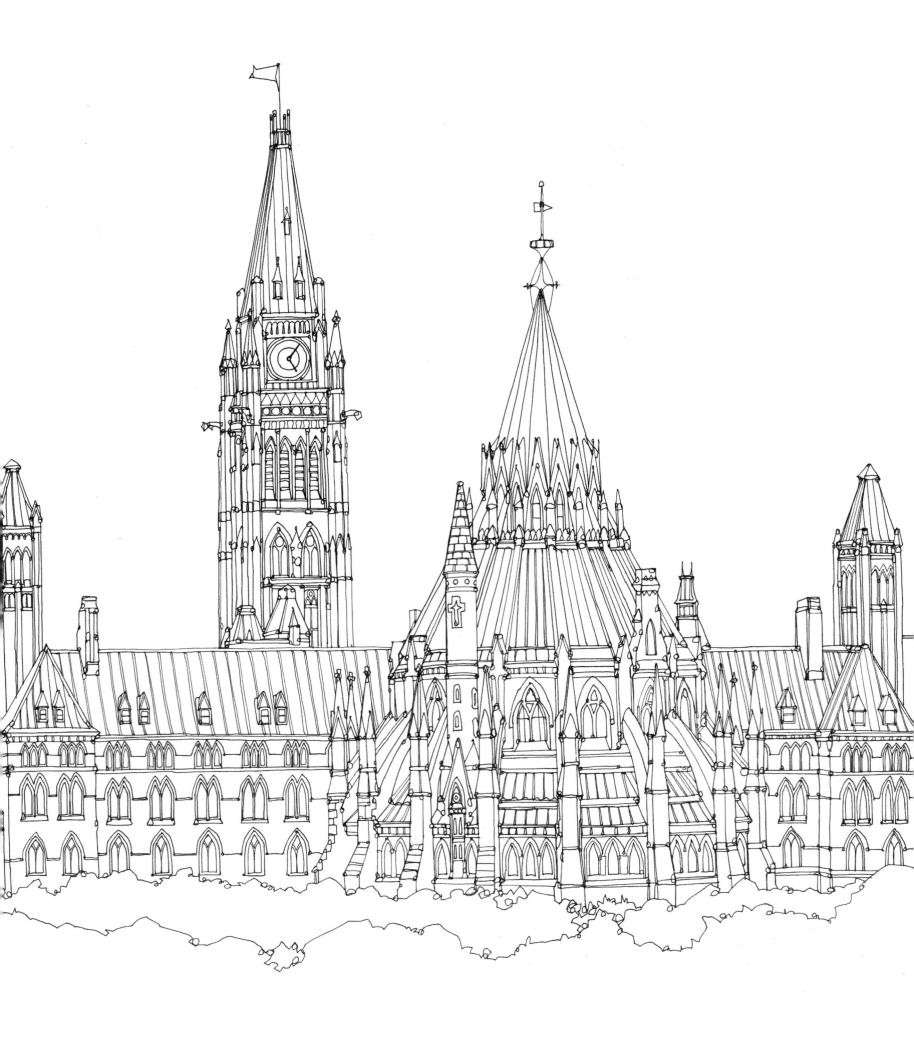

CARBIDE & CARBON BUILDING
1929 | Chicago, Illinois, USA

This 500-foot (150-m) Art Deco office tower was originally built to house offices for the Union Carbide & Carbon Corporation, an expanding chemical and polymer company that is still operating today. Built with a polished black granite base, the main body of the tower is made from dark green terra-cotta with gold-leaf detail and at the top sits a tower made entirely out of gold leaf. Legend has it that the architects intended it to resemble a champagne bottle, with the green exterior as the glass and the golden tower representing the shiny foil top. In 1996 it was named a Chicago landmark and since 2004 has been home to the Hard Rock Hotel.

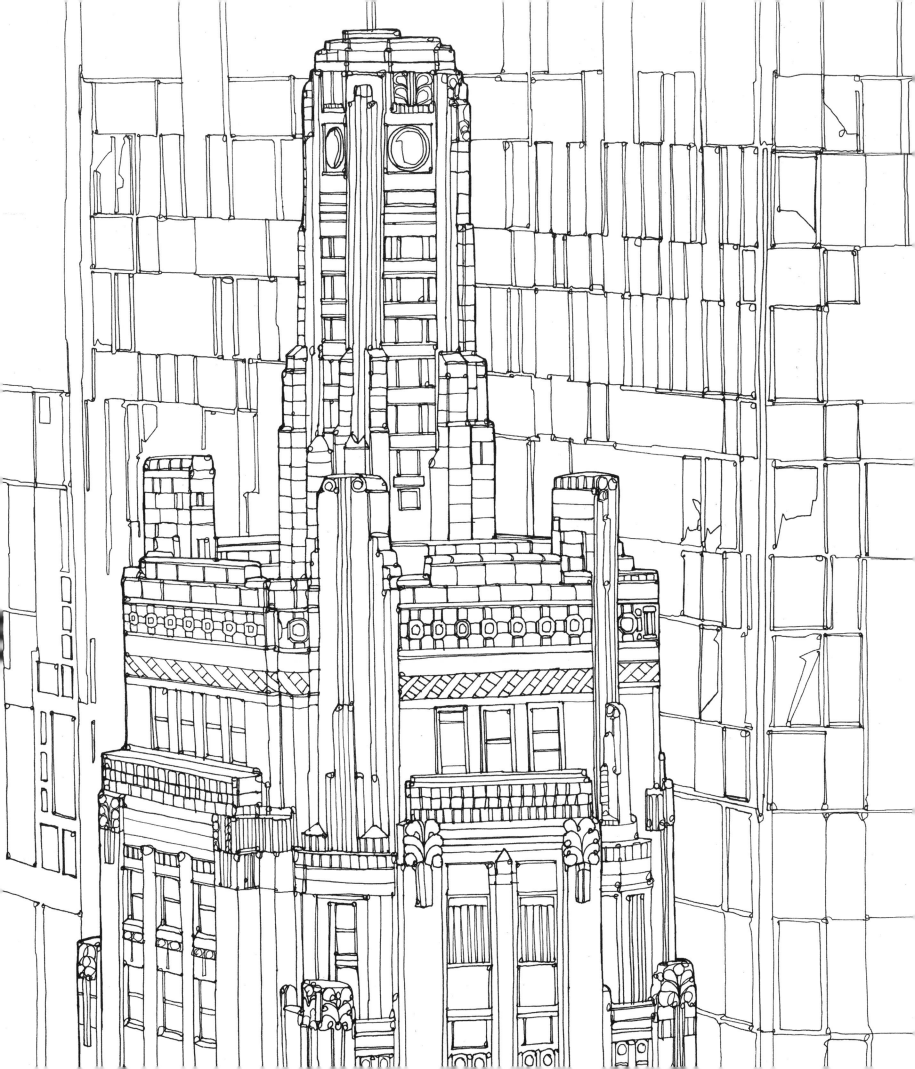

MARINE BUILDING
1930 | Vancouver, Canada

The Marine Building in Vancouver is one of the finest examples of Art Deco architecture in the world. Designed to represent the maritime history of the seaport city, the building's terra-cotta tiling depicts designs of marine life (lobsters, turtles, crabs, scallops, seahorses, and starfish) as well as famous explorers and steam transportation themes. Particularly striking is the green-and-gold main entrance: the central feature is a relief of Captain George Vancouver's ship, surrounded by intricately carved brass and terra-cotta friezes and bas-relief panels of Canadian maritime history. When the Great Depression hit in the thirties, the building's lavish appearance scared tenants away because they assumed the rent would be too high, so the owners ended up selling the building at a loss. Today, it has regained its status as one of the premiere office buildings in Vancouver, and has been featured in numerous films and television productions.

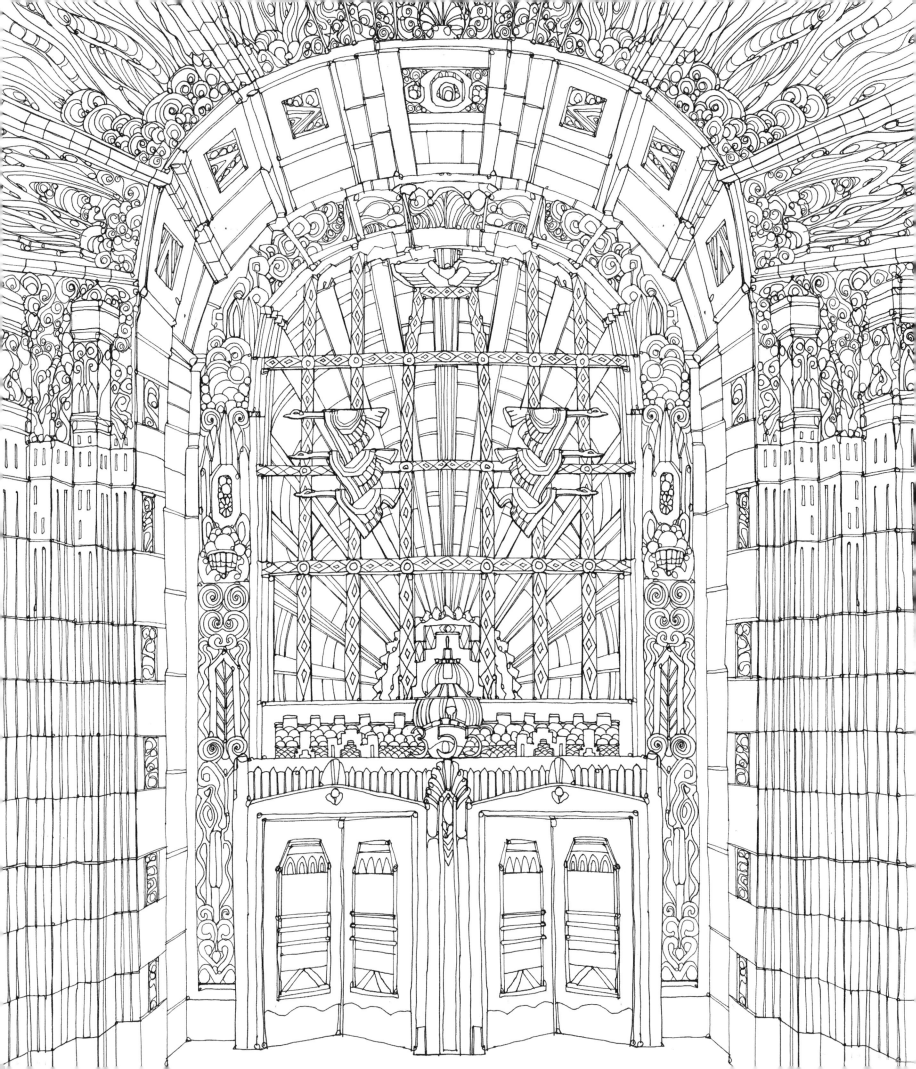

CHRYSLER BUILDING
1930 | New York, New York, USA

This iconic New York skyscraper on Lexington Avenue at 42nd Street is a striking example of Art Deco architecture and the automobile age. Originally conceived as an office building by developer William J. Reynolds, wealthy car manufacturer Walter P. Chrysler bought the building and it served as Chrysler's headquarters until the mid-1950s. The spire, designed in crescent-shaped steps, has a stylized sunburst motif, and below it steel gargoyles in the form of American eagles watch over the city. Although it has since been surpassed by taller buildings, the 125-foot (38-m) spire was added to make it the tallest building in the world and it was the first man-made structure to stand taller than 1,000 feet (305 m).

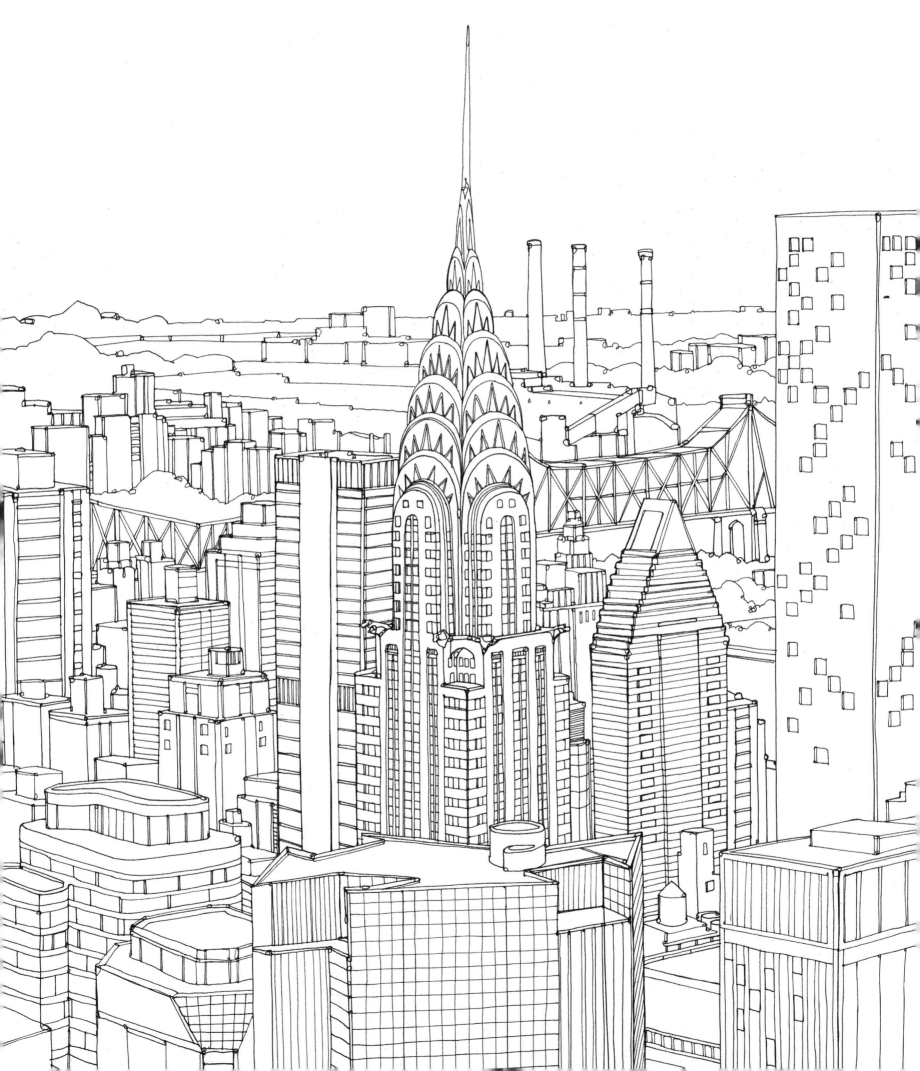

EMPIRE STATE BUILDING
1931 | New York, New York, USA

This Art Deco masterpiece, located in midtown Manhattan on Fifth Avenue between West 33rd and 34th Streets, is an instantly recognizable symbol of New York City known the world over. It stands at a height of 1,454 feet (443 m), and was built to eclipse the nearby Chrysler Building as the tallest building in the world (since surpassed by the World Trade Center, and now the Freedom Tower). When the Depression hit America in the thirties, the office spaces were difficult to rent, but the observation deck saved the day, because masses of people flocked to take in the breathtaking views of the city. The tourist landmark has become a popular place for wedding proposals, and since 1994 the Empire State Building allows weddings to take place every year on Valentine's Day. Featured in countless, films, television shows, and books, the iconic building is known for its tower lights, which are changed almost daily in recognition of different holidays, organizations, and occasions throughout the year.

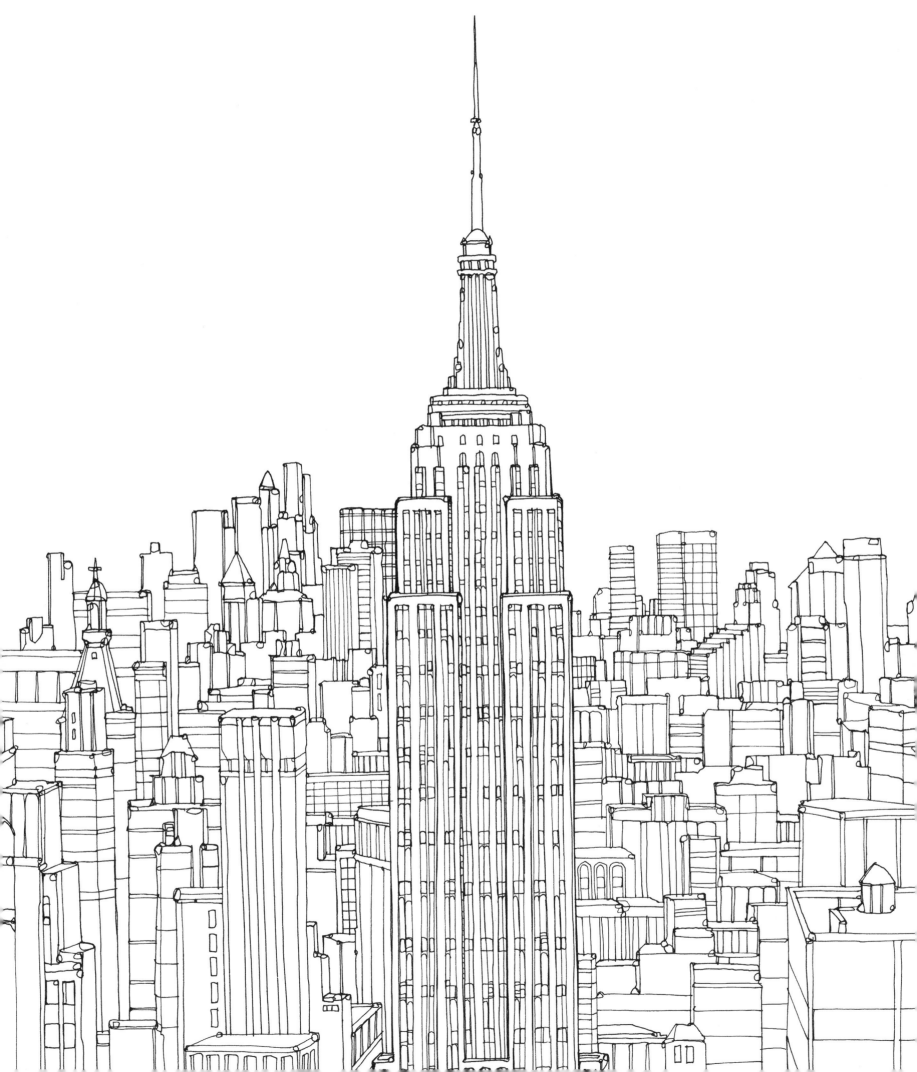

PALACIO DE BELLAS ARTES
1934 | Mexico City, Mexico

This grand, domed palace was commissioned by Mexico's president Porfirio Díaz to replace the previous National Theater that was demolished in 1901. Although the first stone was laid in 1904, the Mexican revolution stalled construction completely between 1910 and 1920, so the building was only finished in 1934. The grand exterior reflects the Art Nouveau style, while the interior is mainly influenced by slightly later Art Deco trends. Particularly impressive is a stained-glass curtain in the main theater depicting the landscape of the Valley of Mexico in a million pieces of colored glass. Today the Palacio hosts exhibitions and shows, and regularly features concerts by the National Symphony Orchestra, as well as performances by the Ballet Folklórico de México.

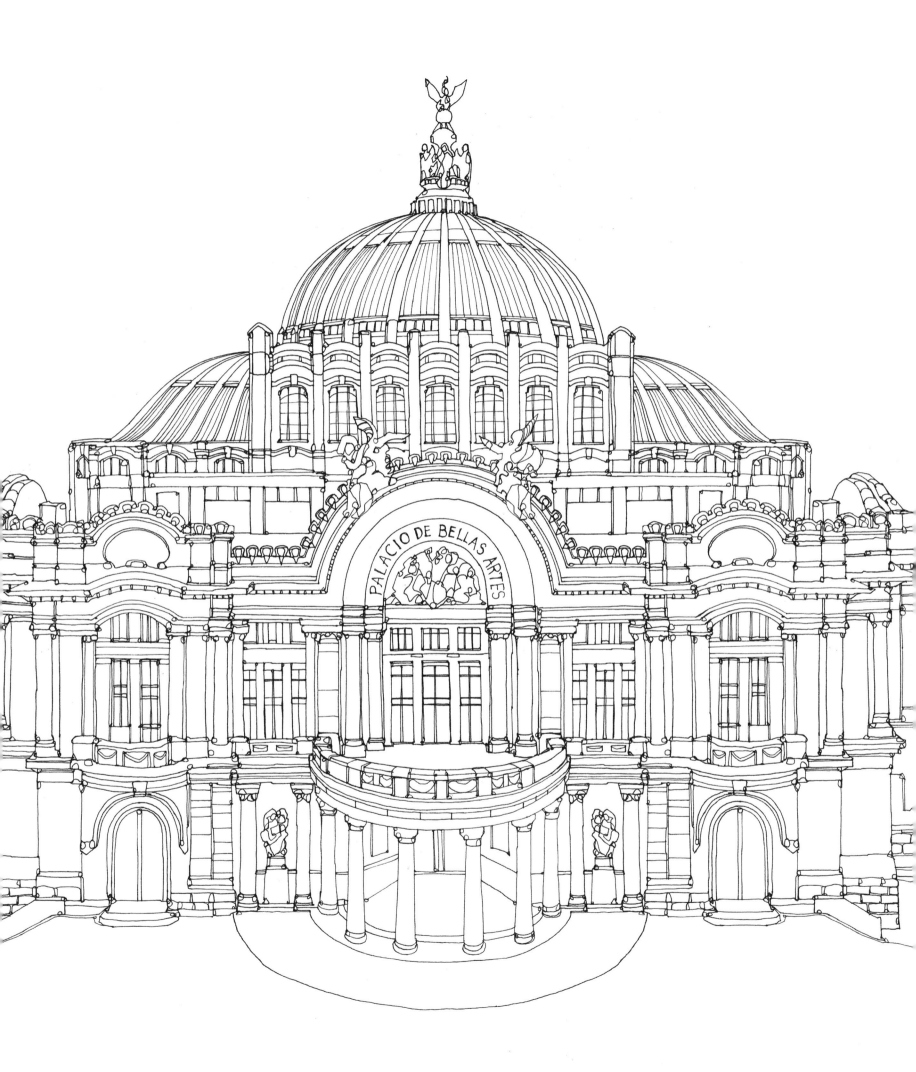

FALLINGWATER
1939 | Mill Run, Pennsylvania, USA

Fallingwater was commissioned by the Kaufmann family, owners of a
department store chain, as a vacation home and an escape from the
pollution of Pittsburgh. The Kaufmanns already owned a stretch of land
in rural Pennsylvania, which included a tumbling 30-foot (9-m) waterfall.
Renowned architect Frank Lloyd Wright responded with a daring modern
design consisting of cantilevered floors in light ochre concrete and red steel.
His aesthetic of "organic architecture" demanded that projects be integrated
into their natural surroundings, and so, rather than simply building a house
with a view of the waterfall, Wright decided to build the house on top of
it. Fallingwater has been open to the public since 1963 and it was awarded
National Historic Landmark status in 1966.

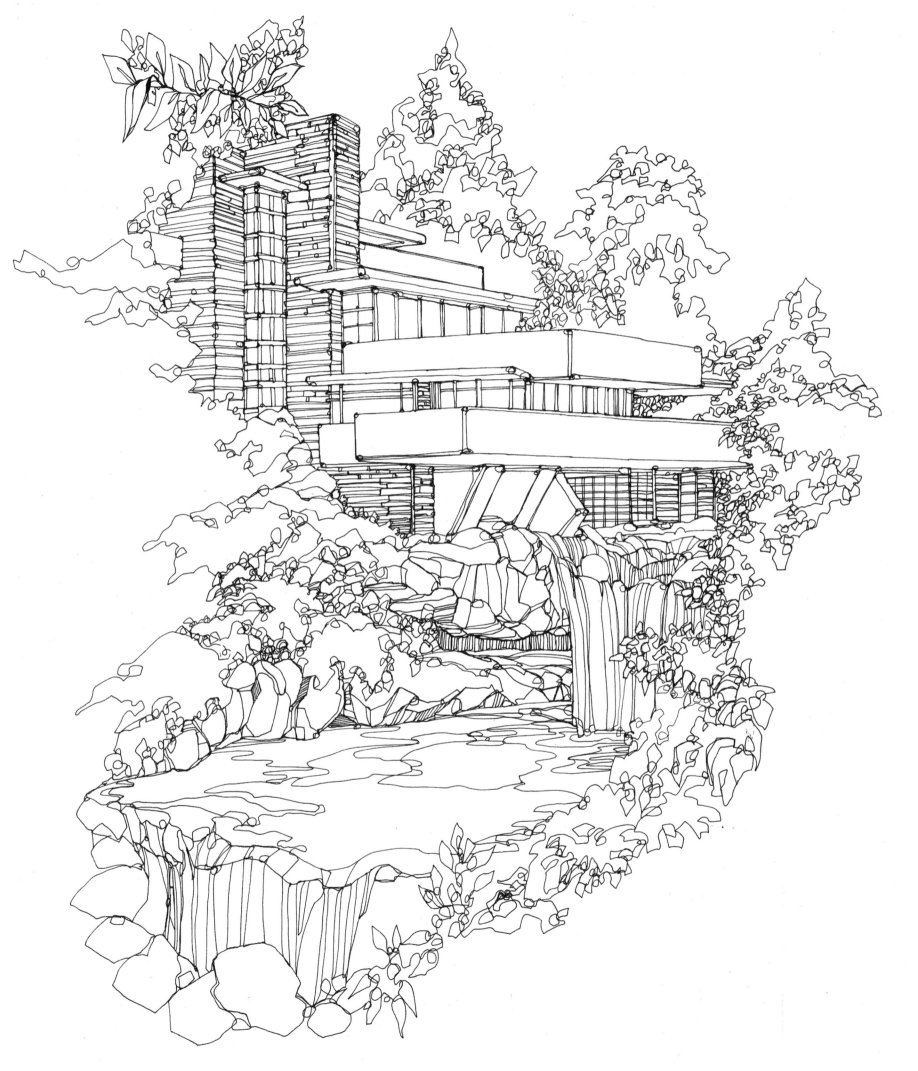

Santuario de las Lajas
1949 | Ipiales, Colombia

Las Lajas is a neo-Gothic cathedral built on a bridge spanning a river gorge just outside the town of Ipiales near the border of Colombia and Ecuador. Legend has it that in 1754, a woman and her deaf-mute daughter caught in a heavy storm, took shelter in the gorge. The women felt a voice calling to them. The daughter looked up and saw an apparition of the Virgin Mary on the rocks above, and suddenly she was able to hear and speak again. This miracle inspired the building of various temporary shrines at the site, until the early twentieth century when donations from local parishioners enabled the construction of this remarkable Roman Catholic cathedral, which balances precariously 150 feet (45 m) above the river below.

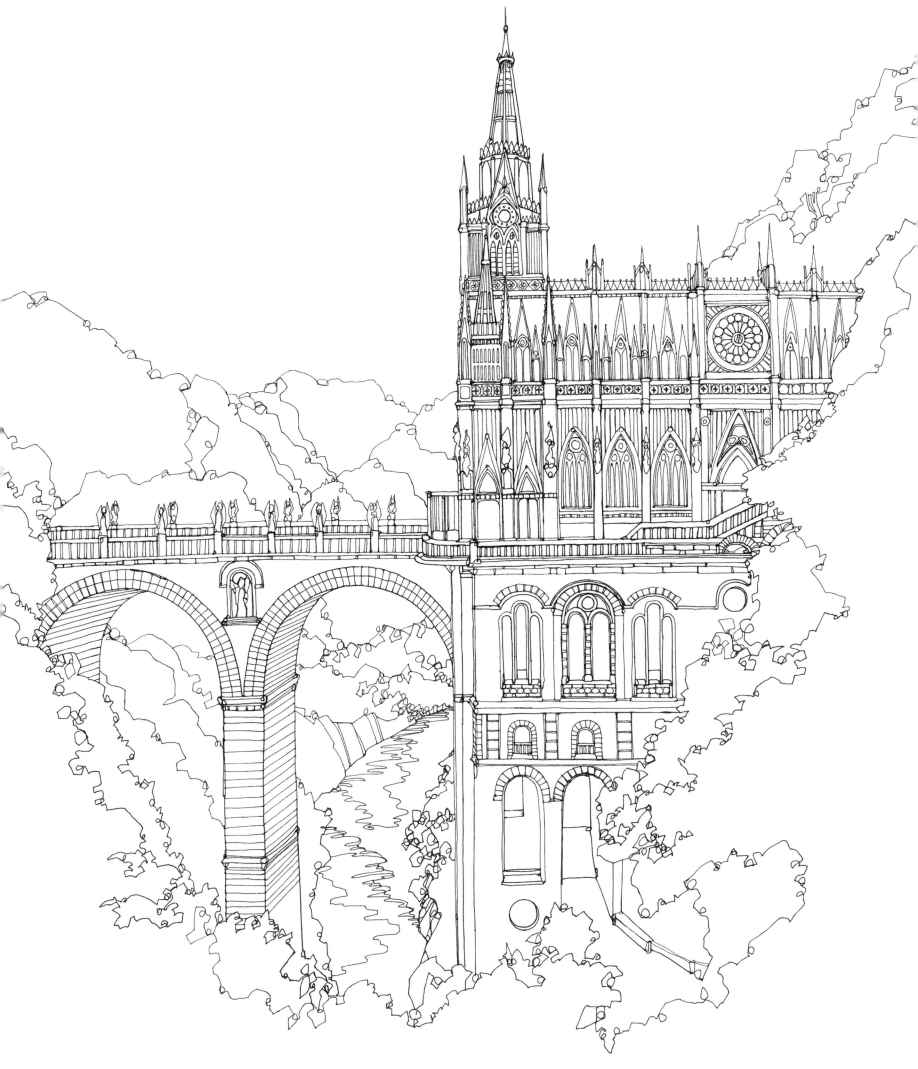

SYDNEY OPERA HOUSE
1973 | Sydney, Australia

When UNESCO officially designated the Sydney Opera House a World Heritage Site in 2007, Danish architect Jørn Oberg Utzon was one of only two architects to have received such recognition for their work during their lifetime. His mammoth Opera House is one of the defining landmarks of Australia and is easily recognizable to millions worldwide. Utzon's father was a naval architect and his influence, along with that of his native seafaring Denmark, is unmistakable in the billowing sails of the building. He also embraced the Nordic love of natural forms and sought to incorporate them into his designs, with the silhouette of the opera house elegantly echoing the fractal structure and outline of a seashell.

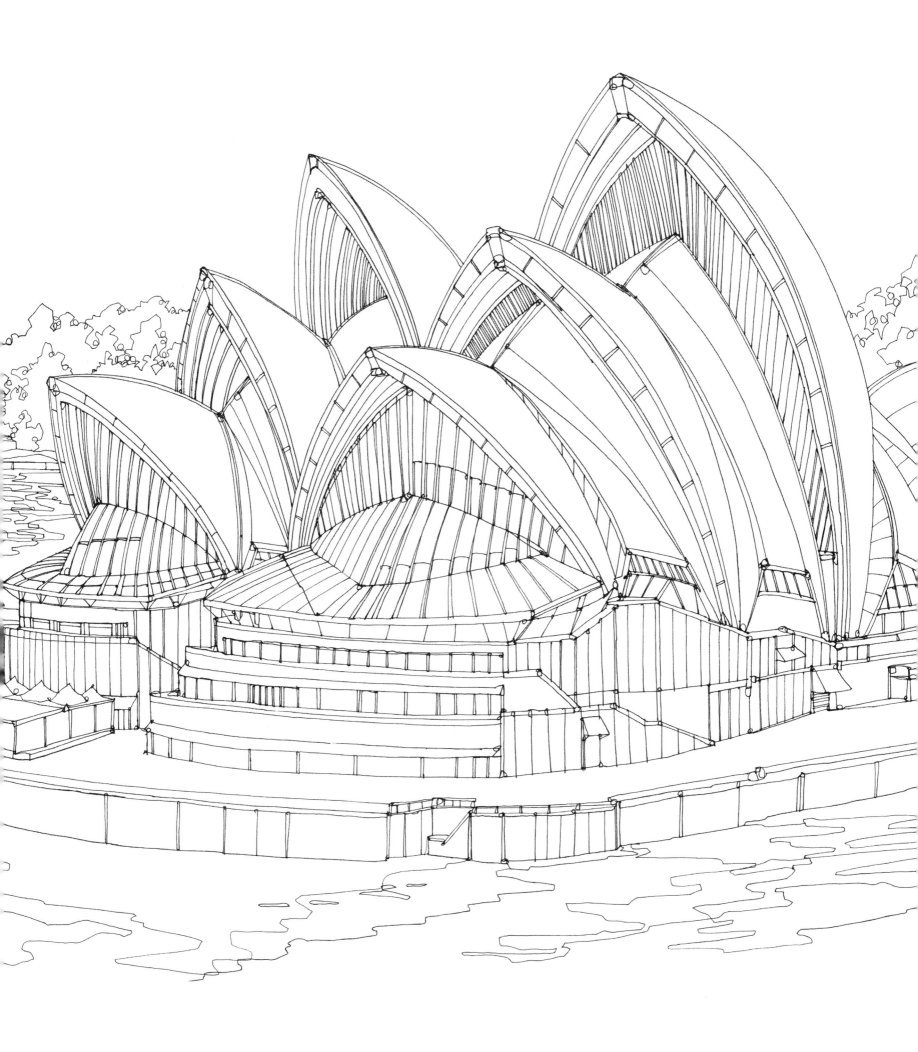

PYRAMIDE DU LOUVRE
1989 | Paris, France

The Musée du Louvre on the bank of the Seine in Paris is the world's most visited museum, with millions of visitors every year. The museum holdings began as the personal art collection of the French king, Louis XIV, and opened as a public art gallery in 1793. Within a decade, Napoleon's spoils of war had swelled the Louvre's collection (which famously includes Leonardo da Vinci's *Mona Lisa*, the *Venus de Milo* and Johannes Vermeer's *The Lacemaker*) into the world's largest. The proposed addition in 1989 by Chinese-American architect I. M. Pei of a "Pyramid" entrance caused controversy for its contemporary architectural style, but the airy structure has since been embraced as a landmark of this most elegant city.

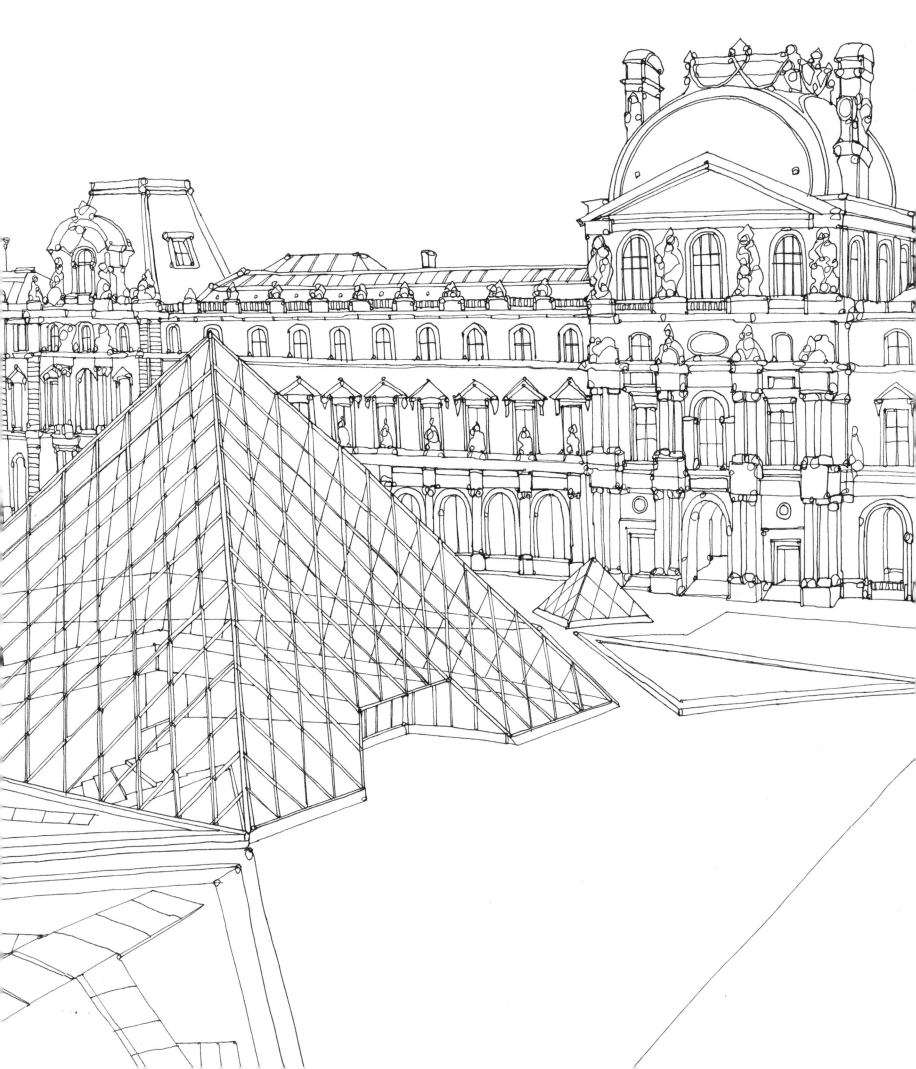

INDEX

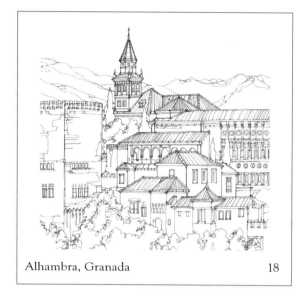
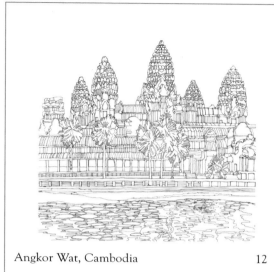
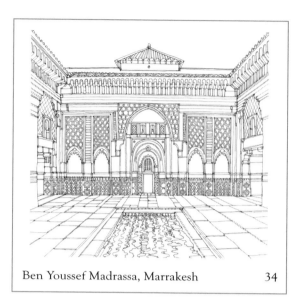
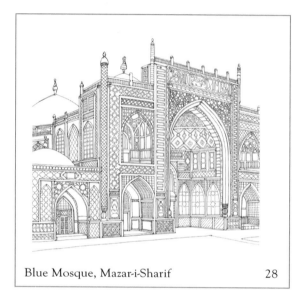
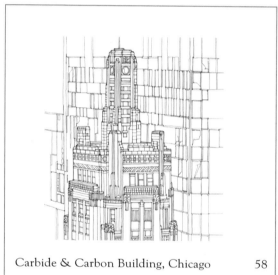
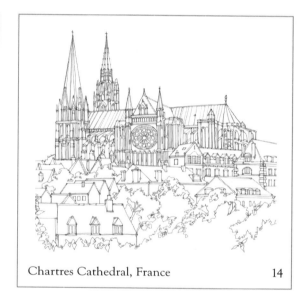
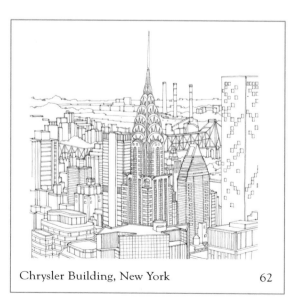
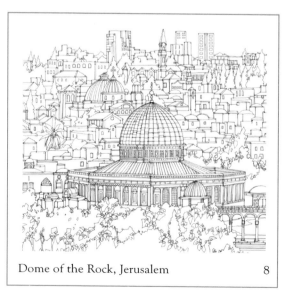
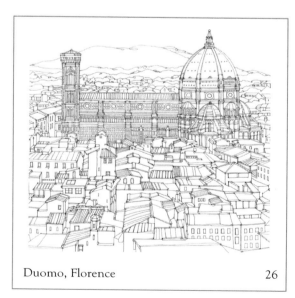

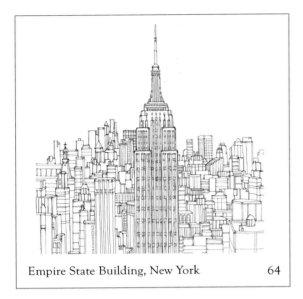

Empire State Building, New York 64

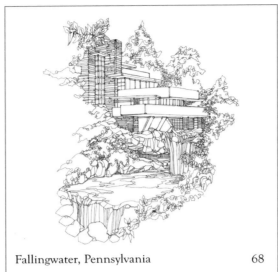

Fallingwater, Pennsylvania 68

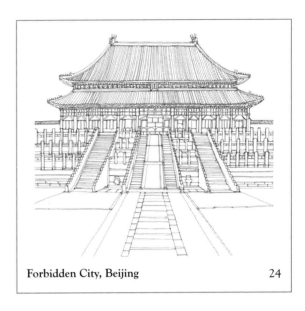

Forbidden City, Beijing 24

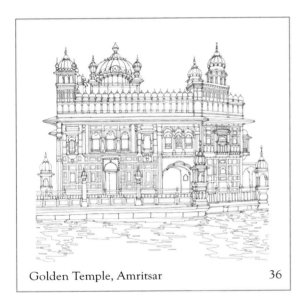

Golden Temple, Amritsar 36

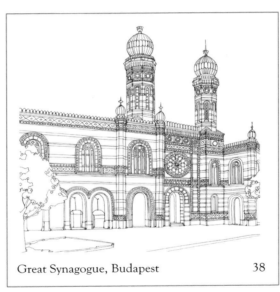

Great Synagogue, Budapest 38

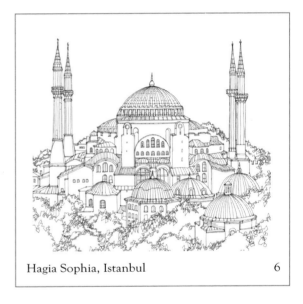

Hagia Sophia, Istanbul 6

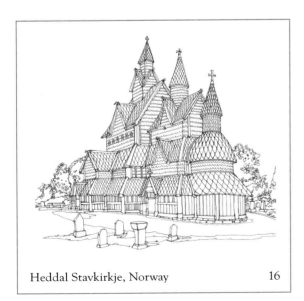

Heddal Stavkirkje, Norway 16

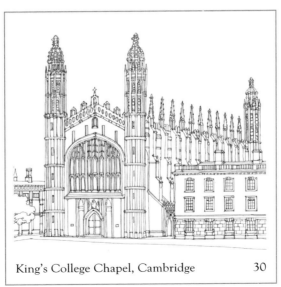

King's College Chapel, Cambridge 30

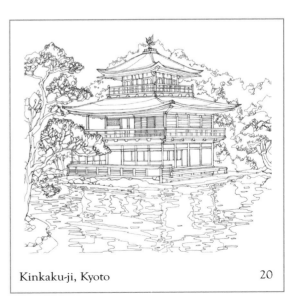

Kinkaku-ji, Kyoto 20

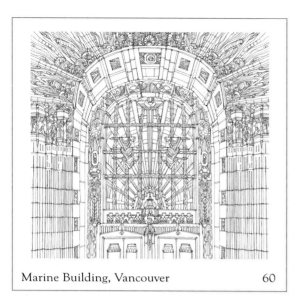

Marine Building, Vancouver 60

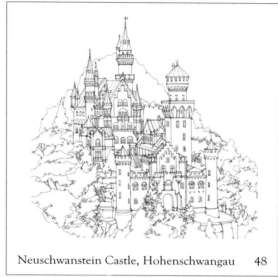

Neuschwanstein Castle, Hohenschwangau 48

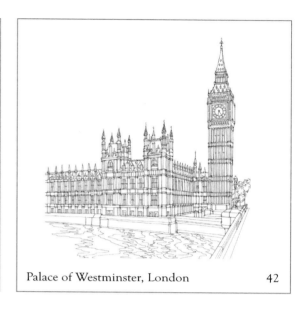

Palace of Westminster, London 42

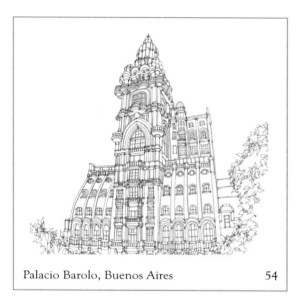

Palacio Barolo, Buenos Aires 54

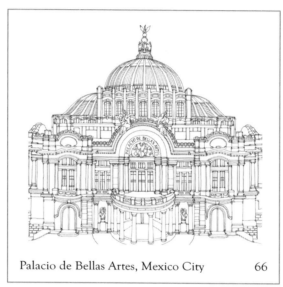

Palacio de Bellas Artes, Mexico City 66

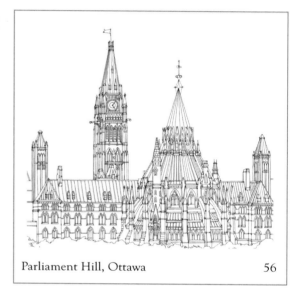

Parliament Hill, Ottawa 56

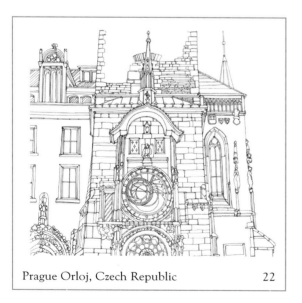

Prague Orloj, Czech Republic 22

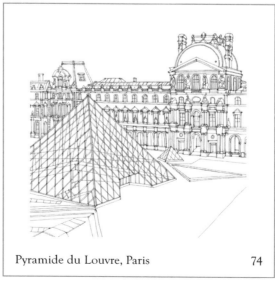

Pyramide du Louvre, Paris 74

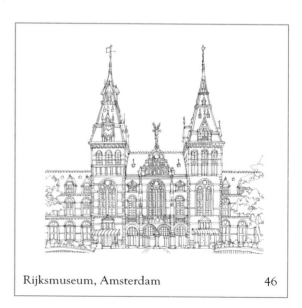

Rijksmuseum, Amsterdam 46

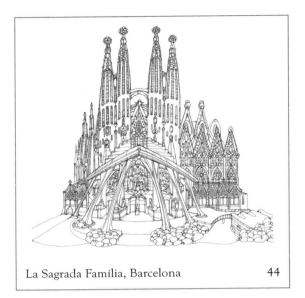

La Sagrada Família, Barcelona 44

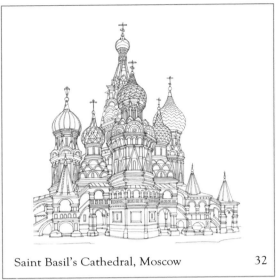

Saint Basil's Cathedral, Moscow 32

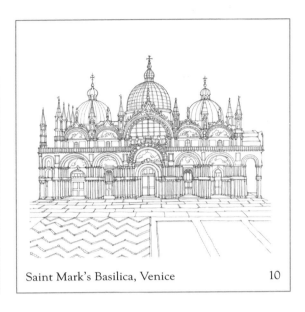

Saint Mark's Basilica, Venice 10

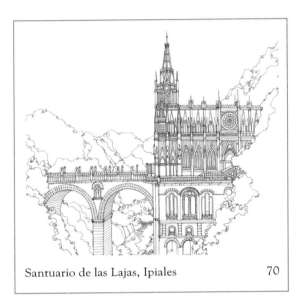

Santuario de las Lajas, Ipiales 70

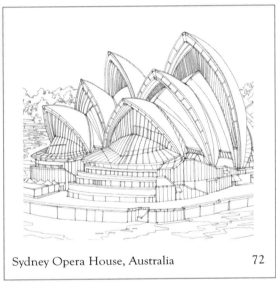

Sydney Opera House, Australia 72

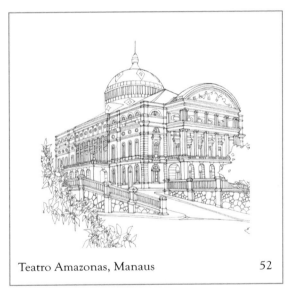

Teatro Amazonas, Manaus 52

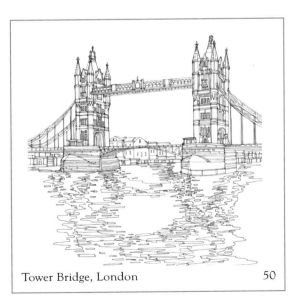

Tower Bridge, London 50

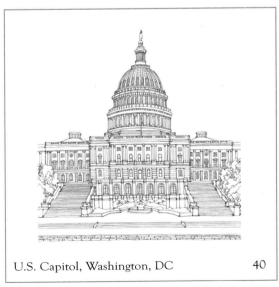

U.S. Capitol, Washington, DC 40

An Imprint of Sterling Publishing Co., Inc.
1166 Avenue of the Americas
New York, NY 10036

ISBN 978-1-4547-0991-6

Distributed in Canada by Sterling Publishing Co., Inc.
c/o Canadian Manda Group, 664 Annette Street, Toronto, Ontario, Canada M6S 2C8

For information about custom editions, special sales, and premium and corporate purchases, please contact Sterling Special Sales at 800-805-5489 or specialsales@sterlingpublishing.com

Manufactured in Singapore

2 4 6 8 10 9 7 5 3

sterlingpublishing.com
larkcrafts.com

Author's Acknowledgments

Dedicated to Stuart and Joseph for all their support over the years.

And also to my mother and father, the first people who taught me how to draw.